This copy
for BECH
& Tim
with my
warmest ⟶ michael
12'17
@ OXFOW ST.

longowed—

MICHAEL FRANCO'S A BOOK OF MEASURE:

THE MARVELS
OF DAVID LEERING

PRESSED WAFER BROOKLYN

ISBN: 978-1-940396-36-1
First Edition
Printed in the United States of America

PRESSED WAFER
375 Parkside Avenue, Brooklyn, NY 11226
www.pressedwafer.com

The provenance of the manuscripts for Mr. Leering's Tales can be found at their conclusion [see page 57]. The book's title is of course not at all from the pen of Mr. Leering: In actuality it originated after a dinner party at the Kael/Basart House in Berkeley where the second and third stories were read aloud and a facsimile manuscript edition of twenty-six copies had been distributed to the assembled guests.

At that time we were still employing the title *Three Brief Encounters* when circulating the manuscript [this being prior to the discovery of the fourth story later that year].

It was during what had been proposed as a brief question and answer period that a Mr. Nathan Coombs, who being rather excited by the stories, asked a series of "gorgeous questions" (according to Robert Frye), in the midst of which he began to refer to the Tales as *"The Marvels."* In a swift evolution he went from the proclamation that the stories were "marvelous" to "the marvelous stories of Mr. Leering," to *"Mr. Leering's Marvels,"* and then simply *"The Marvels."* All this was uttered with such a "contagious exuberance" that the editors, in responding to him, began to adopt the title as well. At their next meeting it was realized that they were all referring to the following text as *"The Marvels."*

A FURTHER NOTE ON THE TEXT FROM THE FIRST EDITION:

David Leering believed as indeed this editor does, that "the actual breakthrough which Miss Dickinson accomplished was to open the Field of a text to a notably different Intimacy through the complete use and "miss-use" of *all* of the textual elements available to the writer. It was and remains, in my mind, as different and exciting as that moment of the movement from black & white to the Color of the Oz sequences in the 1939 film of The Wizard."*

It has then been my working model that the desire for a readable text should not in any way circumvent this sense: Yet I am also keenly aware that Mr. Higginson wrote with much the same sentiment to Miss Todd regarding their own editorial decisions. None-the-less it remains my hope, as the scholar and poet George Butterick noted regarding his transcription of the *Poetry and Truth* lectures of the late Charles Olson, that I have indeed "left in the difficulties."

S. Brown, Berkeley

*Leering Notebook 2, page 153. Text is the terminal entry in this notebook. It is removed by ten or so pages from *The Reality of Reflection* and is written upside down in what appears to be red flow pen. SB

facsimile of original title page

Mr DAVID LEERING:

THREE BRIEF ENCOUNTERS

THE ILLUSION OF DISTANCE

THE ILLUSION OF PERSPECTIVE

THE REALITY OF REFLECTION

GREAT PACIFIC HIGHWAY BOOKS

OAKLAND

2000

‡Across hunting run down like a rabbit in
June air the heart repels the ravages
of collecting days and staggers to thwart
further the ascending landscape of discovery
that awaits each fresh daylight.
Do you then wander or to rephrase do you then have
Strength to Wonder and in so doing wander on alone?
Or will you let twine bind you into a collection. Bend
down Old man beneath this freshening breeze and let
down let down the loose verse of a turn toward the sun
and it will renew you.

ROBERT STILLTON:
Orlando

*THE ILLUSION OF DISTANCE
THE ILLUSION OF PERSPECTIVE
THE REALITY OF REFLECTION
AUTOGRAPH

they say every distance is not near

FROM A DISTANCE Time takes forever or takes up no time at all and that is the problem.

That there is no beginning which I can imagine in my mind which does not split like thick hair under the weight of even the slightest focus, further exacerbates everything.

Add to this, as I do, the fact that is Habit: so basic, so primary, that to say that habit is the d.n.a of time does not exaggerate its absolute command on my perception.

And to this then add the final Fact: Within each city in which I have lived, all of the habits, all the lives, all of those daily

adventures which take place for each of us between the bath-room and the bedroom, between work and home, between the moment of laying one's head upon a pillow after a horren-dous day of work and that imperceptible moment in which we cross into sleep and instantly awake into a new day: all of the habits and adventures of any number of people, from dear intimate friends to mere acquaintances; such as the red-haired girl named Kit who cashiered my groceries every monday after-noon each week for 8 years, or the woman with whom I lived for ten years or so, twenty years ago closeted from the horrors of the seventies in a disintegrating farmhouse in the east bay hills, who now thirty years after our relationship began resides in another major American city in a house I have never set foot in and with a job and friends whom I know only by place or name delivered by her voice on the phone: All of the varied strands which twist and split to form the structure of Habit and so the structure of daily living and its inhabitants, *all* have gone merrily on without me, not only long after my departure but even instantly there-upon.

It makes me think and that is the problem as well. Thought casts itself out of the mind on the thinnest of lines like a fly-fisherman's neatly tied decoy; and while it may at first soar high ever higher, extent and the wisdom of water always await below: Which is to say that there is no thought not tied to an expectation of its liquid fate.

David Miller was not so far away from my own thoughts as I might have liked.

I am old enough now to have felt the assumption of my own uniqueness flow from me like a tide which can be seen running though a narrow passage. But Miller blurs everything.

That we shared a name simply clouds the inevitable.

David Miller was a man who seemed comfortable in his own skin yet recent events have betrayed the error of this particular line of thinking as well.

Habitually David Miller arose and settled into bed at the same hour each day: eleven a.m. one-thirty a.m. a nap if at all possible at three. He ate three meals a day at three distinct and unalterable times. Coffee was served in the morning. Espresso or herbal teas in the afternoon; tea, always, at night.

Whether dining alone or with friends he set a table, poured wine, brought in a flower or two or arranged a budding branch in one of the numerous earthen-ware vases he had purchased from the street vendors in Berkeley when he lived there while teaching contemporary literature at Mills College. He manufactured dense and unique breads; baking once a week near always on a Wednesday. In the afternoons he would walk down to the small farm stand not far from his cottage and return with

selected fruit. I say selected as each piece was chosen by color, shape and finally smell. Arriving home he would arrange these fruits into wonderful wooden Vermont made bowls in a fashion that beckoned notice and rejected any sense that one could remove a piece casually. There was a pumpkin which survived on a stand in his living room until well after Christmas.

The Symphonies of Gustav Mahler were favorites and he lectured me often as to how they could be "read" as a whole work: A notion which I thought fatuous until I actually sat down, only a week ago now and listened to each one straight through over the course of the following three days.

He recommended this with Wagner's Ring as well, claiming that to sit through its entirety as he had done, one opera each week for four weeks in a row when the San Francisco Opera's production had been broadcast live on KDFC, libretto in hand and preferably with a head-set on, the sound of the audience reacting to the giants, dwarfs, gods and dragons residing only within the limits of an imagination; was an experience that was as he put it "essential for anyone who wants an understanding." He never said of what. This proclamation was always as well as frequently put just this flatly, without quarter, room for discussion and certainly without question. I have not been able to set aside the four nights let alone four weeks in which to do this as yet.

There were three fine prints on the walls of his house: a Baskin lithograph, a Bruce Conner lithograph and a small unique

image from a series of engravings produced in Venice by Vincenzo Cartari in the mid-sixteenth century.

He kept a sturdy stack of aromatic wood for the small woodstove that occupied an entire corner of the living room and which provided a curious outdoor feeling to the cottage. He was content to use it for heat and passionate enough to open the large windows that filled the front room so that he might simply create an atmosphere by lighting a fire; this despite the fact that it was merely a cool summer evening. It was not at all unusual to have a distinct mix of wood-warmed air mingling with the damp cold of incoming fog and these were the best nights: And as the cottage was just close enough to the bay, on certain nights when the wind was just right the great fog horns could be heard calling and answering in the confused watery air over the looming pops and hisses of the burning embers of hard-wood.

When I met him he lived in the small cottage in Alameda which was behind the home of an elderly Portuguese woman, whom I knew only as "Katie." I spoke to her only on those occasions which allowed us to pass by one another: or rather I would pass while she sat on her front porch. Leaving her I would make my way down the flowery cement walk courted with daffodils roses and a simply huge Bird of Paradise which nestled just opposite a thick and twisted Meyer lemon tree, each of which in my memory now seem to have been perpetually in bloom or

laden with aromatic fruit. Perhaps they were. I do not remember making this passage with the distinct exception of this last time, without a distinct contentment arising in me.

Estelle Wentworth had married David Miller several years after her first husband, Theodore, had succumbed to a fall from the attic of their summer home in a small town near the pacific coast north of San Francisco. "He just landed wrong," the Doctors had told her: And that was that. Three days later she was returning from the funeral. When she arrived home, after the guests had departed and the phone calls had ceased, she awoke on what she came to call "the first morning," to discover that every habit; whether a house-hold chore, her route to work, the placement of a porcelain coffee cup upon a table at an angle so as to elicit the full range of morning light and so its pleasure, a favorite television show or a trip into the City to the Surf Theater for a Bergman festival or a showing of City Lights; each and all of them had been contorted beyond all possibility of reclaiming their former pleasure and so then would require a complete and unflinching reinvention. It was a realization which had caught her near as unaware as had her

husband's sudden death. It left her angry, bereft and soon so deeply depressed that she stopped going into her office and basically ceased to leave her house for nearly two years.

By the time her old friends had realized the trouble that she was in, their own habits had moved along their own time-line and relocated their daily living beyond the reach of the dark gravitational pull of hers. She remained spoken of with great tenderness while being virtually ignored. In time guilt exerted its own pull, but everything was now a tangle of hurt feelings and wrangled histories of who had called who last. Had it not been for her dear friend, an actor named Will, (whose last name never appears in her journal nor in the course of any of the testaments offered later by the friends, but we presume it to have been Kelty), everything might have soared along from years into decades had he not single-handedly decided to put a stop to "all of the hurt."

"He told me that all I needed was a dinner out. Simple as that. One dinner out and everything would get "back on track."

"I met David," she told me again and again, "over a luscious piece of Prime Rib. Never has anything been so settled for me as was the future of that moment. He wore a tie and a vest that was too small along with a large rather funny, (given our location) overcoat which flowed as he walked as if it were a cape but wasn't. He "liked," he said, when Will teased him a little about it, "the shadow which it made." I began then and there to address him as "the shadow." We were intimate that evening

and we did not spend a night without each other until he left, two years later almost to the day. It was raining. I still do not understand what happened except to say that life intruded as it is apt to do."

Friends were at first appalled, especially her old production team assistant Sara Johnson for whom the whole thing was scandal enough to end their friendship: Yet it was not so appalling as to prevent her from talking to the gossip-press about it. Even when Estelle and David Miller were married early the following year, Miss Johnson never quite recovered from the abrupt beginning of their relationship. "It was my generation," Estelle told me, "a bunch of two-faced hypocrites who on the one hand embraced all manner of illegalities; drugs, alcohol and the like while on the other becoming ever increasingly more conservative and what's worse. . . . judgmentally, pre-emptively conservative. Good riddance. That's all I say. Good riddance."

But while these same friends were appalled by the blunt nature of the beginning of the relationship, they were silent at the quiet abruptness of its demise. So then the relationship that began in the mute abandoned world which had followed her first husband's death, returned her, upon its own passing, directly back to where she had been: Which is to say without the company of old friendships and with the life of her daily habits in bereft disarray.

David Miller, despite his recent separation, referred to Estelle Wentworth often enough. He did this generally with warmth, tender humor and only an occasional foray into a perfectly acceptable and understandable reference as to the troubling nature of maintaining relationships. There was never, at least within my hearing, a hint of meanness. If anything, one noted a perpetual tone of loss underlying everything.

As for Estelle, unlike the period which had followed the death of her late husband, whose name she could not even bear to speak, (and so, at least within my hearing, did not,); after the initial disruption, she chose a third path. Upon finding herself back where she started from, she struggled for a brief time and then, shaking off the would-be ravages of lurking depression, she returned to, renewed and then continued on voraciously alone with the daily life which she and Miller had collected over the course of their two year marriage as if Miller were merely away on a brief Journey or errand and was expected imminently or at least within the foreseeable future.

It was during this time that I met Miss Wentworth. I was attending a showing of a new print of City Lights, out by the beach at The Surf theater. There was a small party which followed the

film in the home of Eugene Marker, a former college professor. He spoke so eloquently before the show and in his Stanyan St. living room afterward, that one was at first filled with expectations of the film which we were about to see, ("the document" as he called it); and then left with both a desire as well as a feeling of wonderful responsibility to go back and view it all over again. "Then," he said, his back leaning against the Victorian mantel of his fireplace as he stood beneath a magnificent Hockney poster for *PARADE*, his hands clasped behind his back, "and only then will you in any real way begin to see what Mr. Chaplin has accomplished here." "If then" Miss Wentworth had merrily offered. To which Marker had replied, "Indeed, Miss Wentworth is quite correct, if not graciously conservative in her estimation." He said this with a notable respect in his voice. The remark garnered a warm knowing laugh from one small section of the room: A response which was at that time as mysterious to me as it was to the remainder of the assembled guests.

I was standing beside her as he spoke. When he had finished I had asked her how many times she had in fact seen City Lights. Her response while not in the least offensive was completely dismissive and ended the subject. "Oh now that really is a bore. So what do you do young man," she asked warmly. "I ask boring questions," I returned. "Now young man," she shot back, "don't get yourself offended." Then whilst simultaneously surveying the room and leaning over so that she was very close

to me she whispered, "Don't tell Gene, but I have only seen it twice... at least in *this* form," and she giggled and took me by the arm. She continued looking around the room until she spotted Marker at which point she proclaimed "Gene, this one's mine," to which he had nodded as he began to announce dinner and herd us into the dining room.

The two of us never stopped talking: she asked a stream of questions and I answered each one. At the end of two hours I knew only that she was "well over eighty-five," (astonishing) recently separated from a slightly younger man named David, (perhaps more astonishing), lived north of the city, still had the home in the Los Angeles area which she had purchased when she first got married and that her love and knowledge of Chaplin, even if her dates were, as far as I knew, all off by a year or so, was exceptional if not unique. That was it: for although this may sound like a great deal of information, it was in fact mostly surface. There simply were no details offered to bring these facts into any kind of relief.

She asked if she might call me to come for supper and I gave her my phone number. She did not give me hers and I did not ask for it. This in fact, looking back on everything, began a pattern from which I never escaped. Even on those occasions when I actually asked her direct questions about her early life or her family, I was always thwarted.

Recent history, by which I mean within the last three years, was another matter. Over the course of that dinner after the

film, the phrase "when David and I" was so often repeated that "David" began to seem familiar.

At the end of dinner, Mr. Marker offered us a fabulous port from Harris –a reserva no less and the creamiest crème brûlée, made by his friend Dina, a pastry chef visiting him from Boston, with whom I had a wonderful discussion later about Proust, (an author whom I had not at that time read yet like so many would-be intellectuals, knew of) and her grandmother's abiding passion for him. While Dina and I were discussing her recent journey to Paris, a large square man in a perfect suit had begun to take notice of me and I of him. Suddenly a tall thin actually spindly woman named Sarah poked her nose into our conversation and asked abruptly enough where Dina had stayed. "44 Rue Hamelin" she replied. At Bethenea's? she shot back. "Of course, where else," Dina whipped back and then they both laughed uncomfortably and I stood there for what seemed an eternity before the great square man who had begun to listen to our exchange turned to me, stepping in between Dina (firmly now in the clutches of Sarah) and myself and pronounced himself to be David Miller. "A pleasure," I said holding out my hand to his great square fingers. "Let's see how long I can live up to that," he replied smiling.

We talked easily which made his intrusion desirable. It was all small talk, the film, the evening, how to truly *look* when watching a film and so on: all of it fluid and interesting.

In a poem which I was reading just before I began to write this all down, it says: *"life is a stretched bow/ and only the empty string/ sees in the dark target/ Conclusion."*

But I digress. At some point I saw another friend and excused myself and that put an end to our fine conversation.

The evening ended well past mid-night and somewhere in the shuffle of gathering and departing I ended up standing next to Miller again where I discovered that he intended to take a cab back across the bay to Oakland. "Nonsense" I interrupted "it will cost you a fortune. I am happy to drive you." He reluctantly accepted and ten minutes later we were heading towards the on-ramp for the Bay Bridge. After the initial continuations of his previously initial protest regarding my inconvenience; an offer to pay for gas, (rebuffed with prejudice, "christ" I said "I am not 18 anymore" for which he apologized several times), we fell into a silence. I drove and we each periodically chatted whenever he wasn't so terrified by my driving and the late-night Bridge traffic that he could not bring himself to speak.
What is remarkable is that we were not uncomfortable in these silences.
The east-bay spread out in a lush array of lights and dark both of which extended high up into the night sky and across the tree-stubbed extent of horizon before us. Above the lights, the hills onto which the lights, tiny and various, crept higher each

year, glowed in the brown-black: Above the hills the deep night sky and above that those stars which had reached high enough to escape the silencing city lights.

Suddenly out of this articulate quiet his voice with neither drama nor affect spoke:

"Our city lies about us
murmuring, drifts in an evening humanity"

"Oh–" I questioned.

"There is a wisdom of night and day,
older than that proud blaze of sun,
in which we rest, a passion, primitive to love,
of perishing, a praise and recreation of the sun.
My earthly city is revealed in its beauty."

"What is that?" I asked him. "Robert Duncan," he crisply replied. "*Heavenly City/ Earthly City.*" "That's quite a mouthful," I said, "and you remember it all." "Oh, that's just the end; but it's also all I remember. At some point after they built the lower platform on the Bridge I was coming into the city and the first lines just came back to me and have ever since . . . at least on the good days or nights- like this. After I saw the announcement of his death in the Chronicle a while back I went up to the third floor at Moe's in Berkeley and asked for his work. They sent

me over to Serendipity Books- that gentleman in there -Mr. Howard was his name if I recall- is the closest thing I will ever come to a character like Vollard- the guy who sold Picassos and Cézannes in Paris before everybody proclaimed them. Mr. Howard keeps his books the way some men keep fine wine. He's not cheap by any means, but he has collected the writers of his generation and he keeps them with a respect that creates respect if you know what I mean. Anyhow I gave him the line, which I only had in my memory from years ago god knows where- must have been when I was at Berkeley that I read it- but it was a poem that had just stuck as things sometimes do and he immediately had a book in his hands actually three copies of varying condition and price, one of which was open to the passage. Each of the volumes despite the variance of their condition sold for several hundred dollars. When Mr. Howard saw me blanch at the consecutively increasing prices, he produced a fine volume of collected poems from the late '60's which in good condition sold for $45.00 & which he offered to me at a ten percent discount. That was the beginning of my reading through his work, all of which I purchased from Mr. Howard– at least what is available or affordable. One would never think of a writer disappearing because the reader cannot afford to purchase a book: but that can happen."

We began the descent from the bridge and having passed the toll plaza made the turn toward Alameda, where Miller's house was; loping down the Nimitz Freeway's ever teasingly strange

convolutions which always felt as if one was crossing a body of water in a small power-boat. We took the Tube and emerged into the motionless city on Webster St. David directed me. We chatted. I drove.

We arrived at his little house at 901 Delmar shortly after one a.m. He invited me in. In the dark the foliage that surrounded the path back to his house seemed strange and exceeding. I felt like a student invited to the home of his teacher. We entered through a little foyer with a built-in seat and coat-rack which faced an ancient mirror whose reflection was so tangled in age that it was difficult to actually see one's self in the dim entry light. He quickly set and lit a fire in a small wood stove and fetched two glasses and a bottle of wine and a small hunk of creamy cheese whose french name I do not remember.

From there with the small fire blazing-away we sat and talked with the greatest of ease until three-thirty. It seemed suddenly as if we had always known each other and his interest in what I did and how I afforded to do it, fed my ego a warm rich meal of itself. When I prepared to depart I realized that I had in that time asked him virtually nothing of himself, his life, his cares and with an embarrassed flush I said so. "Oh don't think a thing about it. Estelle always said I pried too much. I hope I haven't done that again. "Estelle," I asked. "Do you mean Estelle Wentworth."

"Yes of course," he replied. "You were talking with her earlier so I assumed you two knew each other." "We only just met"

I managed as the realization bubbled up from the painfully obvious and burst over me. "Well she is a fine lady; you will enjoy knowing her."

But it was too late to really respond or ask questions. In the time necessary for this conversation and the connection to be made between Estelle's "David" and David Miller, I was suddenly out the door.

The night stretched itself across my notice. The air cool and near wet owing to the near-by yet not as yet over-spreading fog, was laced with the hint of the bouquet of his garden. I felt myself turn, headed I do not even now know where.

Two weeks later I was awakened by an early phone call. It was Miss Wentworth. "Do you feel like dinner with an old lady or are you simply too busy." "Name the day," I said and she asked, "Would today be possible."

"Today- ." I was a little shocked. After two weeks I had all but given up any notion that I might be invited. I had not heard from Estelle or David for that matter. Before I could say more she explained that she hoped I would not be put-off but she had prepared a meal for friends coming in from Paris and one of them had taken ill, leaving Estelle with an entire dinner for three and her friends holed-up in a small hotel in the City.

"I was not," I assured her, "in the least put-off." Frankly I was quite content to have been thought of.

"Come at 6:30 if that is all right." It was and I did.

The drive up to Napa was, given the hour, rather painless. I went the back way climbing up out of Oakland to Highway 24 where I passed through the Caldecott Tunnel; a tunnel which always has the feeling of Passage to me.

San Francisco, or as I should say, the Bay Area, (as indeed all of California), is a Place; a Place which one enters through very specific portals: For the state herself it is Ocean, Mountains or Desert that *must* be crossed: in the Bay Area it is the Marin Headlands to the Golden Gate, the mammoth planes of the Sacramento River Delta and her attending bridges, the great marsh and mud flats that surround the edges of the South Bay on both the east and west banks, or the Oakland Hills with its canyon-filled highways; none of which is more powerful in its definitions of entrance and exit than the Caldecott Tunnel: Yet regardless of Ocean, Mountain or Desert there is, it seems, always a narrowing; as if whatever river or current or path has carried one toward the Golden State or The City, it must, before reaching its destination, negotiate a given physical division point.

The long mute illumination of the tunnel seemed then to propel me out of the safe harbor of the City and into the other world of the inland valleys. I crossed from sunset into twilight

with deep dark on my right and that very specific western blue fading on my left. At the horizon which was dominated completely by the breadth and height of Mt. Diablo, a single star slowly gave way to two and then a glimmer of thousands. I crossed the Carquinez Straits of the Sacramento and took the turn-off just north of Vallejo toward the Napa valley.

Tired of the silence I turned on the radio: A Little Night Music was playing, which made me laugh.

The exit itself was filled with memories of my child-hood, as it was here that my father would turn the car off the main road and head across the foothills into the Napa Valley and so to his boyhood home where my Grandmother had lived since 1918 (and where my grandfather- long dead & held in my mind by a single memory had been born in the late 1880s).

In memory it was as indeed it was tonight, always cold when we made this journey. I followed his route, taking the short-cut down Mini Street (my paternal grandmother's maiden name), a left at American Canyon, (a name which indicated great wild-ness in my childhood mind), just where it spilled out into the valley proper and rejoined the main road. Turning away from my Grandmother's side of the valley I crossed the Napa river south of town and headed up-valley.

Estelle's house, a tall thin yellow Victorian with blue trim and fabulous scroll-work on the eves, stood north of the city of Napa itself in the smaller town of St. Helena: 1910 Charter

Oak Ave to be exact. She and David Miller had purchased it the year they were married so that the two of them would have someplace to go which was neutral: a Place which they could create in the time they would have as a couple. For two years they had wintered here; arriving in September and departing in late April. They spent the remainder of the year in the Pasadena House, where they each took care of such business as they still maintained, or at Miller's small house in Alameda. For Estelle's part, work was, at this point at least, ceremonial. Following her first -husband's death and that dark period which followed it she had slowly reconnected with what remained of the production company, which she had maintained following her formal departure from a long held position in, as she was to put it to me that night, the "original Hollywood community." She did not elaborate on this except to say in an admonishing tone which silenced further inquiry: "Let's just say David, that I worked with people who were to film what Stieglitz was to Photography or Miss Stein to literature and leave it at that. I do not trust the past. It has a nasty habit of nibbling away little bits of today."

I arrived almost ten minutes early so I took a slow walk around the block. The quiet of the December air called attention to itself. There were wonderful vegetative smells and traces of wood smoke. Two teenagers walking hand-in-hand. Several dogs who trotted over to check me out; oak trees over-spread the

street their branches bare and severe tangled in the darkening twilight sky.

I rounded the corner and returned to the house walking up the small brick walk-way which had two small onion lights illuminating it. I felt small as I stood at the door: Small in stature small in life. As I thought of Estelle Wentworth I could not imagine anything from my own life which might be of interest to her. I felt myself slowly receding into one of those strange places which I all too often arrive at when I literally cannot think of anything that is not some anecdotal bit of fluff, which has been often, too often told, & which has the immense power to illicit silence from the most productive talkers. Dear god not tonight I thought to myself: at once realizing that I had actually muttered the phrase aloud. This plunged me deeper into myself as I was gripped with the possibility that she had heard me. But there was no response from within and the silence in-turn calmed me a bit. I knocked again and this time discerned movement.

Miss Wentworth arrived and opened the old door with a gentle flourish. "Ah Mistha Leering," she proclaimed, her accent floating on ever so slight a hint of the north-east. "And right on time how charming do come in." The house was simple and lovely. It was decorated I immediately recognized with East Lake furniture through-out: Literally everything, she later told me, dating from the mid 1890's which she said mirrored her parents' home.

We went directly into her kitchen which was fully equipped, full of light and windows and had plenty of room to work. She offered me sherry for which she peeled a small piece of lemon zest, her hand slightly shaking as she did. As she finished off her dinner preparations she began to ask me about my life while she bustled from sink to butcher-block to refrigerator talking as she did with an amazing energy. Finally after twenty minutes of culinary abstractions (dicing, alchemical concoctions and the like,) she pulled six luscious oysters from the refrigerator and proceeded to open them with the skill of a veteran. One of the little sauces she had composed was delicately laid atop each briny open shell. I was handed a bottle of '79 Saint-Aubin to open. "I know it's not a valley wine but with the guests from France I wanted to show them we actually drank their wine too, at least before I laid something decent from up-valley on them" she said with a chortle. A minute later we assembled ourselves in the small coffered-ceilinged room. In the corner of the room was a wonderful fireplace which she had already lit and from the ceiling hung a fine oil lamp which actually produced a great deal of light as well as warmth. On the walls, which arose white and spanish-mission-like above old wood wainscoting I was stunned to find a wonderful Chagall lithograph from Daphnis & Chloe; an artist's proof signed by Chagall with a small inscription to someone named Maureen, from Teriade; apparently one of the printers at Mourlot. There was also a relatively early Picasso which I knew to be from the Vollard

Suite. A single flower stood in a small vase on the large dining table. On the opposite wall was a large deeply impasted oil painting of a man, his face turned away from the viewer, sitting alone in a field of pumpkins: He stares deeply into the far field toward an oak tree that is bathed in gold, clutching on his lap, a large pumpkin. Next to the painting hung a small framed neatly typed statement which read:

FIG. 2

But the artist should realize from the failure of his allegories
how little the public demands of this sort of thing.
Who gives the trouble to read in the
allegorical paintings…what
the artists have intended to make known?
All these enigmatic figures make a burden of what
ought to amuse or instruct me…
Since the sole purpose of the painting is to show me
that which can not be said in words,
it is ridiculous that an effort should have to be made
in order to understand it
…and ordinarily, when I have succeeded in divining
what these mysterious figures mean, I find that
the substance has not been worthy of so elaborate
a concealment.

"Do you like my Pumpkin Field," she asked, returning to the room. "To be honest I am not sure. But it is curious" I said.

"Which is exactly what attracted me to it," she replied. "What's with the little statement over here," I asked pointing to what I had just read. "It is part of the painting: Came with it actually. The text is written out by the artist on the back of the canvas." "I am a little uneasy with painters making with the words," I said. Without pause she replied firmly yet very gently, "I don't trust an artist who limits any direction that expression wants to take." I had to think about this for a moment and I found myself struggling to reply. "We don't need to argue this," she said laughing a little, "the fact is that I don't anymore. It just got boring. I love it. I love the image. I love the paint. I love the cantankerousness of the statement." "I do like the painting," I proposed "I . . ." but with that she stopped me. "Let's eat," she said and down we sat to our glorious oysters. They were the first of several lovely courses: Simple, delicate, beautifully prepared.

The conversation flowed with ease. We talked about small things. She described her morning walks to me: Everyday without fail, unless of course there was a deluge, she took a small path out across a vineyard toward the foothills of the eastern mountains that framed the valley. "I get just high enough to see something," she said. But it was everyday for the season: up by seven, shower & walk and then home for a small pot of coffee, fruit bread and cheese. This was followed by an hour or so of reading then lunch at one. The afternoons were without structure.

The talk of her life went on for some time and then almost as an afterthought she said: "Any of us can be careful; but being careful usually pushes one up onto the riverbank. But if you're willing to suffer a little embarrassment, take a chance in other words– then you just might have one of those experiences which other people read about in old books. Now I do not mean that one should be careless. One must as a habit always travel with a very certain care for yourself and for others as well. But you also have to step out into the traffic of the world: you don't just wade into the river willy-nilly but you gotta get wet. At least once-in-awhile." With this she laughed.

It was at least eight-thirty before the name "David Miller" slipped into our conversation. I did not mention him of course; that was for Miss Wentworth: And when the phrase "David and I" supplely slipped from her mind it was notable more by its previous absence than any improper feeling that the actual phrase engendered. Yet once spoken, once the mental gate had been opened, the name escaped again and again and frankly again over the course of the rest of the evening until, had I not known better, I might reasonably have assumed that she and David Miller still resided there together: It quickly became obvious that so completely interwoven into every thought or discussion of her daily life was the presence of David Miller that it could not be extracted.

She again began to ask for the details of my life: "Not that stuff you tell other people, I want the real stuff," she said in reopening the subject. Yet following each of my answers, which I attempted without much success to keep short, (one of the other down-sides of not getting out much), she would offer a densely detailed anecdote from her life with David Miller. Each sequence of questions, I realized well into the pattern, started and stopped in this way: and the detail which I gleaned from her descriptions of their daily living together would be worthy of Proust; which is to say I was told everything from the time they awoke to their morning conversations to the path of their walks through the town, to the coats purchased by Miller directly from a fabricator in Europe which kept the fog at bay and so on.

I mentioned my short visit with him, the drive, the poetry. She seemed to ignore the fact of the visit and the like, pausing for a moment of what appeared but remotely on her face as confusion before then seizing upon the word "poetry" as if it were the only interesting or understandable point in what I had been relating: "Oh all that came natural," she said, "he knew professor Parkinson you see and Thom knew the lot of those renaissance boys in Berkeley. That is where my pumpkin comes from. The painter lived with one of the poets. I can't for the life of me remember which one. But it doesn't matter."

It was near nine-thirty before she slipped a pork-roast onto the table as the main course, admonishing me as she did to save room for mousse. The roast was luscious; served in small slices upon a bed of Tuscan beans. It had been stuffed with red pepper, leeks and cheese, rubbed with a paste of garlic, paprika and olive oil then slowly roasted. A small simple artichoke sat to one side of it and she sliced a thick and uneven piece of bread and plopped it upon the outer edge of the plate. "The bread comes from my friend Francis down the street: she supplies everyone on the block these days." It was wonderfully tasty, a rough crust with a nutty overtone and just a hint of what I realized after several bites to be grape.

Time dissolved. We proceeded on through dessert talking about a wide variety of subjects always arriving back to home-base which is to say David Miller. At around eleven we cleared everything off the table and I volunteered to help wash-up. I noticed at this point that she had begun to fade a little and I had a slight concern that I had kept her too long.
"Why don't you stay the night..." she suddenly said, "there is no need for you to drive all the way down to the City this late." I hesitated. She offered again, urged me a little and I agreed. I was quickly settled into a corner room on the upper floor which looked out over the street and had a fine view of the vineyards beyond, which were just visible beneath the cold December half Moon. The little house settled and deepened

into a quiet. I grabbed a copy of Emma Figs' *LIGHT* from a bookshelf that ran along the length of the bed and read for a while, caught by the romance of lunch with Monet. I dozed and read for an hour until I was unable to keep my eyes open or to be accurate open them to begin again. I turned off the glass-shaded brass Mission lamp which stood firmly on a wonderful table next to the white plump bed I was nestled into and finally slept soundly.

I awoke early and found myself in the middle bedroom of my grandmother's house in the east Napa hills; my head– cold, the house silent. My mother and father were not awake but I could soon hear my Grandmother in the kitchen drawing water, rattling a pan, singing gently under her breath from time to time. A door closed and I heard my dad's low voice offer a "good morning 'ma" and I was up in a shot to get in there, fumbling for slippers and a robe. I was greeted with a gentle always gentle "hey buddy" and a wrap of his great arm around my small body. I was content to sit with the two of them as they had their coffee, my back propped against his warm side for warmth, listening to the parade of stories that flowed between them; mostly from my grandmother; but my father would periodically infuse the proceedings with a winding tale of his own. I was given mush (which as always seemed to be

ready and waiting) and the warm steam was nourishing to my self in a way the actual mush could never be. My sole thought during all of this was that my father and I would be going for our walk: a round of calls to the property itself: barn, back pasture, the redwood tree he had planted at the age of ten, and then on to my Great Uncle's house up the hill, with its ponds and animals, returning for lunch before setting out down the road to see "Godfather" Armagnac and his wife who we would drop-in on just after their own lunch. On other days we might take the car up to the top of the mountains just east of the ranch and walk up the old trail set out by his father to the top of our property there.

Breakfast was done and I went to fetch something from my bedroom. I entered the still dark room and closed the door and bent over to look for my traveling bag. As I did this I suddenly felt dizzy. The room turned once, twice and I felt myself plunge into a swoon– slowly falling toward the floor. The impact of the fall was brisk and I opened my eyes to Estelle's guest room, the air cold and quiet.

I ached for my father and grandmother for several minutes: their loss exacerbated by the steady departure of their presence followed by the steady rise of the sense of loss itself, left me lost and empty of my self. I felt light and detached. The air, cold and crisp moved within my nostrils. I took a deep breath, closed my eyes and began to mutely cry. I awoke again to a little sun and the chattering of birds mixed with the sweet smell of cold

and dry fields and the old house as well. There was a low clank from a radiator. I could hear Estelle in the kitchen below me. I forced myself up, dressed and made my way down the creaky stairs to greet her.

From the second landing I could detect the sweet aroma of coffee and warmth just beginning to flow up the stairwell from the kitchen and fireplace. As I entered the kitchen a large porcelain cup filled half-way with coffee was placed on the table in front of me. "Well–" she asked in a very hearty voice, "did you sleep–" her eye-brows rising above her small wire glasses as she asked. "Perchance to Dream" I replied. "Of–" she asked expectantly. "My father," I replied, "and his mother and the Valley itself." "I call that the dream room," she said stepping around what was in my mind the emotional edge in the sound of my voice. "Was it a nice visit," she continued rather matter-of-factly. "Oh yes," I said, "I have enjoyed myself immensely." "No no," she said, "not here; to your grandmother's–"
I saw a way out and I took it: "Always," I said in my lightest voice. This seemed to satisfy her and put an end to the topic.
Estelle seemed revived. Her blue eyes were bright and clear and she moved with a renewed vigor. She sliced a bit of bread and we ate and chatted intermittently for twenty minutes or so.
She went into the other room for a moment from where she called out asking if I wanted to join her for her morning turn. "Your what," I asked. "My walk," she responded. "My friend Ger-

trude always called it that and for some reason it just stuck. We walked every day when I visited her, just before the war and I took up the habit." "Which war," I asked. "Isn't it a horror that you have to ask," she sighed. I hadn't really thought of it but I agreed. "TWO" she stated flatly. She picked up a small black wool poncho and pulled it over her head and said, "Drink up."

We headed across the street and down a thin trail that crossed the vineyard in silence. It took only a brief time before we were climbing. The air was still cold and wet in feeling but I was quickly warming up. The remnants of the half moon were just hovering in the blue-dark of the western side of the valley. Estelle kept up a sharp pace, even for me. Within a very short period we came around the shoulder of the hill we were climbing where we were presented with a marvelous view looking south-west down the valley. Mt. Tamalpais lay at the extent of our sight, her base still covered in winter fog; her peak just catching the first blossom of sun which for us was still hidden behind the range of hills we were walking. Two turkey-buzzards swirled and fetched in the blue air. She stood stock still and without turning said:

My bright soul
returns each day with a day
I sit I eat I still
with consistency
try with bitter humor to grasp
and hold just a wisp of

this air each day in my hand.
Tomorrow I hope to try again.

She stood very still after intoning this toward the waking hori-
zon and then turned to continue our "turn." "What was that,"
I asked. "One of David's poems." "He writes poems too." "Oh
yes," she replied drawing the yes across three or four steps,
"since high-school." "Published–" "Not-a-one. He could care less.
The only reason I know that particular poem is that he gave
it to me our first year on the epiphany." With that she stopped
and held up a finger. We stood like this for a moment or two
before two large deer rounded the path about fifty yards in front
of us. They stopped and stared at us as we in-turn stared at
them. Finally the larger of the two blew a little air from her dark
nostrils, just enough to hear and the both of them turned and
slipped off the path and down the hill; the small one following
the big one, until after two or three rows of vines they turned in
the opposite direction and took up a silent trot away from us.
"Mom is still a little nervous with baby," said Estelle. "By spring
the two of them will saunter right by us like we aren't here."
We proceeded up the trail— –Estelle regaining her original
pace– and walked for five or so minutes until we came to a
divide: one path headed up; the other down. We took the trail
down into the vineyard and were soon headed back in the
direction we had come. We crossed a vigorous creek, edged on
both sides with reddish volcanic rock, on a narrow metal foot

bridge and before I knew it we were stepping out of the field and back onto her street.

"You do this every morning" I asked. "With out fail," she said. "David says that the soul and the body have to be brought back together to renew themselves each day or they will be at constant odds with each other." "Interesting," I said. "By which you mean to say you think it a load of hooey," she snapped with a laugh.

"I think I need to be on my way if you will forgive me," I said. "Nothing to forgive, so long as you give me the pleasure of your coming up here again." "I need only an invitation," I said. She gave me a quick embrace, pulled a small creek-stone from her pocket and placed it into my hand. A minute later I was headed south down the valley, the stone, red and volcanic in appearance, mounted in the empty ash-tray on my dashboard.

It was an invitation which never came.

A traffic light stopped me at the familiar corner of Coombsville Road. A turn east which for forty years brought me to my grandmother would now take me to my grandmother's house, owned now by a rather dear cousin who had been with great care slowly restoring it to its turn-of-the-century California simplicity.

o o o

Two days later when the phone rang at an ungodly early hour, somewhere in the back of my mind I vaguely assumed that it must be Estelle.

"Mr. Leering–" a male voice asked darkly, "may I ask who is calling" I said. "David Miller," came the quick and lighter response. Something in me, nothing strange or alarming but a force none-the-less, pushed my voice and I greeted him as I would an old friend: He invited me to dinner the following weekend and I happily accepted.

I arrived slightly but not obnoxiously late and the lack of parking pushed me a little later than I had been when I arrived. I locked the car which was amusingly unnecessary given its age and condition: But it is a Saab "a '72 Saab," I would always pronounce to myself as if the solidity of the statement infused itself into "automobile"; despite the fact that it was purchased second-hand and was now an antique: a polite way of saying that it was being driven well past its time. I traversed the walk back to his house, Katie yelling a good evening to me from her porch as if my visit was quite normal. The lemon heavy with fruit hung low to the ground, which exposed his mammoth front window creating the effect of a huge aquarium. There is a section of Marcel Proust's REMEMBRANCE, which I am currently reading, in which he describes standing outside of a restaurant at the beach, old, formal, Victorian, which is illuminated like a great fish tank, each of the patrons becoming a

strange tropical variety floating across his view. It is a marvelous scene which I will never lose and immediately on reading this section I had been returned to my initial visit to Miller's little house. It even made me laugh a little while simultaneously making my head swim.

The door was open so I knocked and stepped in.

He greeted me warmly clasping my shoulder as he shook my hand, all the while apologizing that it had been too long since our last encounter.

Dinner was long delicious and so filled with great conversation that I did not want to leave. He promised to call soon, (there was curiously never the offer of a phone number or the suggestion that I might call him). But unlike Estelle, he did call. I returned for a lunch ten days later, dinner a week or so after that; a screening on his large TV of Ken Russell's THE DEVILS and SAVAGE MESSIAH, both, he said, highly acclaimed by Mr. Marker; and both equally wonderful "documents." There was a night for Mahler, a night of endless talk about the San Francisco Renaissance as he called it, (which actually occurred in Berkeley), full of poets I had never heard of and grand stories. A night in which I feared he would toss me out when I professed my admiration for James Joyce whom for some reason Miller could not abide. "I far prefer Stein and will consider forgiving you for your bad taste." The great book for the century was *The Making of Americans*, "not that greek pastiche." He said

this with an uncharacteristic vehemence which further ignited his response to my suggestion that the very idea of "the" great book was dangerous. "I don't fear making judgments and I am always more than happy to proclaim greatness or what I love, why shouldn't I be– it can do *you* no more harm than making you think or at worst disagree."

All in all I must have sat there in his house ten to fifteen times over the next six months: The last six or so occurring on a weekly basis the last two of which were in the same week. How many times, how many occasions, it doesn't matter: Truth be told I don't really know; but it was on the edge of regular or slightly more than regular. It was not every week, although at times it was, but then a week or two would go by, just enough time so that I wasn't expecting his invitation and I would pick-up the phone and his voice, deep, resonant, San Franciscan, would offer up another proposal and before I knew it I would be standing in the brightly lit kitchen; the dark just taking over the evening, the air hesitant, milling between day and night and within, where I stood, the familiar dancing with the new, offering up a relaxed expectation.

He kept a perpetual pitcher of Manhattans in his small ancient and impeccably clean refrigerator. Like a cask of ancient tawny port he never emptied the contents completely but continuously added to it, mixing the new with the old into a potent concoction that could quickly lighten one's mental processes.

More than once I found myself in his small black tiled bathroom having to collect my self with a splash of cold water before returning to the living room and the sweet, dry warmth of the wood fire.

As before the silences which will accrue over the course of any conversation remained comfortable. As before there was never a mention of Miss Wentworth, a fact I noticed and vigorously respected; this despite my confusion, given that it was himself who had originally introduced the subject. The only remnant evidence of their relationship was a modestly frequent reference he made to an undesignated "we": But this would often be corrected in the following sentence as in "we went down to Big Sur and I stayed at THE GULL AND HOOK in Pacific Grove; I was there for near a week." This did not occur often: But it happened enough to catch my ear and the grammatical construction turned any thought of questions into intrusive impossibilities.

Estelle never called. I sent a note of thanks, which for once in my life I got into the mail right away, in which I encouraged her to call me again or to come down herself for supper or lunch. I received nothing in reply. It struck me that she might have returned to Southern California early. But after a month meandered into two I but rarely thought of trying to get together with her again. Such thought of this as there was, was slowly subsumed by the pleasures of her former other half.

January slipped easily into February which was shortly late March which tripped into May and suddenly June with the 4th of July holiday looming. I drove a friend from Boston up to Tuolumne Meadows for a sniff of the high country, being rather proud of myself that we were amongst the first up there that year. We returned to the city before the crowds began their arrival. I spent the 4th with Miller watching a series of the great John Wayne movies: The two of us near sick with laughter at the line "burn me a thick one Smitty," which sent us off in search of other such great moments. I proposed a book to be called the quotes of Chairman Wayne. "Oh no, it has to be Mr. Wayne– no chairman. In fact the cover should say 'Chairman Wayne' and it should be crossed out and "Mr. John Wayne" should be substituted below it in red. We can assemble it and I will take it over to Shoemaker in Berkeley: He will know what to do with it." He even went and unearthed a notebook in which we duly recorded the command to Smitty, along with several other jewels from the evening's film.

I left late that night and cruised home well past two. The days following were a blur of work and appointments broken by the return of my Boston visitor from his excursion south. It was not until the 12th or 13th that suddenly everything calmed down and I was able to spend a relaxing morning reading and sipping coffee. Somewhere around noon the phone rang and while I hesitated a moment to pick it up I succumbed none-the-less.

I was surprised to find that it was Eugene Marker calling. He was brief: glossing across the greetings and requisite apologies for not calling sooner and alighting upon the true subject of his call. "I am actually calling about Estelle Wentworth, we are planning an evening for her and I know that the two of you had met and seemed to hit it off: She also mentioned you numerous times when I last saw her."

"Sounds wonderful," I said. "Is there anything I can do." "Oh no," he said rather gravely. "I could even go up and fetch her if she'd like or—"

"Oh dear you haven't heard have you" he interrupted. "Heard what" I asked. "I am sorry to tell you that Miss Wentworth passed away on the 10th of July, she was home at the time—nothing dramatic she" but at this point the shock, far greater than it should have been, was pouring into me, filling me, raising within my conscious being until from behind my eyes the thought began to push tears onto my cheeks.

I quickly retrieved the details from Mr. Marker, hung up, sat down and attempted to collect myself.

Once I had done so I immediately thought of David Miller of course and I instinctively reached for the phone. Oddly over the months I had never called him: Not once. It took me a minute or two to retrieve the number which I had only because I noted it on his phone one evening so that I could give it to my out-of-town guest in case of an emergency. I dialed and the

phone rang seven times without his answering which caused a flush of panic to course through me: The thought being that in so much as I had never called, (and more importantly that he had never offered me his number) it might seem like a presumed intimacy to do so now. This feeling was inflamed –strangely– by the thought that I could not recall the phone in his house ever ringing.

Two hours later I decided that all of this was absurd beyond my years so I called again: Again I received no answer.

The memorial was set for that Friday evening the 19th and was to be held in the Julia Morgan Theater up on Potrero Hill. Over the next three days I attempted to phone Miller a couple of times each day: On Wednesday I decided to send flowers to him instead of to the memorial and had a small, hopefully tasteful arrangement dispatched that day from the little flower stand next to Cody's Books. I enclosed a small note, quoting my favorite little-known 18th century writer: *"Only in memory does life not hesitate."*

This was met with continued silence.

The evening of the memorial was dense with summer fog. The city after several weeks of fine weather was suddenly subsumed by gray which in the early still light summer evening was equal parts warm and cold. Pure San Francisco I thought as I trekked from my car up to the Morgan Theater.

Where I had expected a gathering of a reasonably small group of friends and acquaintances, I found a crowd: But what I did not find was David Miller; which while seeming odd also and most importantly, equally seemed explicable, given the sudden end to their marriage. The result of all this over-thinking was that I became more concerned that my flowers might have been inappropriate.

For over forty minutes a succession of people mostly elderly bordering on ancient crossed the podium, ordered and introduced by Mr. Marker. All of them had a story, a thought, an assessment; each of which I found dear and worth listening to: a rarity at these events in my experience. Suddenly the rich arch of a life seemed to stand up on its own shaking off the encumbrances of death, loss and aging, before slowly walking away into an unknown future entirely on its own. It was rather amazing. I finally learned of her family, her career in the film industry, her constant aid to those artists whose lives had been betrayed by circumstance, (while in stark contrast her loathing of those who had of their own accord betrayed themselves or others); her work with the production company surrounding Charlie Chaplin, her early connection to whom she had never mentioned to me; her marriages (the mention of Miller, coming only as an allusion to a late life moment of exquisite happiness,) and so on and on. It was like listening to a grand novel whose end nobody mentioned.

At the close of all of this, those of us lucky enough to be near Mr. Marker were issued a lovely book on Chaplin's earlier years which had recently been updated and reprinted, and which contained amongst its treasures, an interview with Estelle conducted sometime in 1919, along with a lush contemporary photograph in which she was alarmingly young and deeply sensuous; which again deepened my sense of her and her life.

I went home, a day or two passed, I attempted to contact Miller again, twice in fact, and finally gave up.

On the day of Estelle's death I had read in the Chronicle's "This Day in History" section, that it was the birthday of the "renowned french writer Marcel Proust," with what I now know to be the requisite mention of the cookie incident: But it was enough to spark my interest and I spent a day or two looking for a good used hardcover copy of *A Remembrance of Things Past*, without any luck at all. Yet I was happy for the distraction and ended up settling for a new yet battered copy of the first of the seven volumes in paperback. Estelle's death while having absolutely no effect at all upon my own life had caused an impact far out of proportion with any reality; as when the bump of a car from behind you in slow traffic sends shockwaves throughout your body as if one had experienced a major accident. Her passing sent me plunging into the comfortable isolation of reading.

A week more passed in which I was slowly drawn into the grand world which Proust created within the covers of the mammoth book. Suddenly the names of Swann, Gilbert, Bergotte, Albertine and Odette became familiar companions of my day. I did little work and went out only for groceries.

On the 6th of August I was still living within this odd cocoon which I had fashioned out of inappropriate grief, (whose grasp still perplexes me), when I suddenly felt the immediate command to go into Alameda and check for Miller at his house. I do not know what stimulated this nor do I now remember, given the events that followed, why I thought this necessary or appropriate: I literally just stood up, showered dressed and twenty minutes following my thought, I was in the car crossing Oakland. I took the Park Street bridge, which gave me a straight shot to his neighborhood on the south shore.

My heart was beating when I stepped out of the car and walked down the narrow path to his house. The curtains were all drawn and the little windows that clustered in three rows across the top of his rough oak front door were dark as well. My flowers stood in the rear corner dried to mostly stems; the little condolence card still held aloft on its thin plastic stake. I knocked. The door sounded hollow like the bottom of a loaf of bread. I waited knocked again and then put my face to the little windows. All I could see of the interior was what was reflected in

the old hall mirror which I had passed by on my visits. But it was so filled with age that I could not even make out the larger furniture or book shelves which had filled the living room. I returned to my car, passing Katie's empty front porch again. Stacked on it were a number of sheets of ply-wood and next to them a small electric saw. Inside, through the window I could see a middle-aged man working on something out of my line of sight. I called out to him several times and when he finally came out he looked perplexed. I casually asked him if Katie was in. He stood for several seconds longer than he should have shaking his head in an obvious gesture of not understanding. I repeated myself asking simply "Katie–" He nodded yes and then at once emphatically said "No– no" and proceeded to rattle off something in a language I assumed was Portuguese. I thanked him and left.

I had already climbed back into my car and fastened my seat belt when it struck me that nothing was blooming along the path back to the house. It struck me so hard that I actually returned to check. There was indeed nothing: not even a bud. The Bird of Paradise appeared long dead and the Meyer lemon tree seemed muted and certainly showed no signs of any recent or future fruit. I was more than befuddled and was now sure that something alarming had taken place.

I returned home and decided to phone Gene Marker. Unfortunately I got no farther than his answering machine, but I none-the-less left a message, explaining that I was trying

to track down David Miller and wondering if he knew his whereabouts.

I gathered a late lunch together and set a fire to take the chill out off the foggy afternoon. I grabbed my Proust but it seemed heavy and labored...too much work for my state of mind. I went to fetch the morning's Chronicle but was distracted on the way by the book Marker had given me following the Memorial service. I opened it and found the interview with Estelle. The photograph which was dated "summer 1919" was a marvel. Strong black and white; an almost but not quite candid un-posed quality; the hint of a laugh being stifled and her left hand ever so slightly blurred as it rose toward a gesture. There was of course a striking resemblance to the woman whom I had encountered more than seventy years later: it was as if I was looking at the daughter of someone I knew– the spitting image as we say. It struck me that I did not in fact know Estelle Wentworth's age and I searched the book for a biographical note. I was a little shocked when I did find a bio note that listed her birth-date as 1898. This would have made her 91. I could hear her voice so clearly at that moment saying "young friend I am well over eighty-five, let us leave it at that." This was followed by a brief description of her relationship with Chaplin, alluded to here as an "intimate working relationship" which surpassed even the testimonies at the memorial; a note about her first husband, "Theodore Grayson [1902–1985], a revered

cinematographer, whom she married in 1922." "Following Mr. Grayson's death in 1985 she married David Miller [1910–1988], a deeply admired professor of English and American Literature who taught for over thirty years at Mills College. She divides her time," the note concluded, "between the Los Angeles area and Northern California."

I winced at the typo listing Miller's death. That's what happens when somebody besides the author collects the details for a reissue, I thought.

The afternoon drifted into the evening and dinner. I retired earlier than usual and slept well.

I awoke early, showered and made coffee. I was still in the midst of nibbling bits of toast and finishing the last caustic drops of my over-brewed coffee when I noticed the message light on my machine glowed with a red "1." I pushed the button, thinking that it was too early for a call from anyone who really knew me. I was still wandering about looking for something when I heard Marker's voice emerge from my little machine: He sounded a little put out. "I don't understand your question," he was saying as I approached the tiny machine which was delivering his disembodied voice to me; "why do you want to know David Miller's–" he paused and then resumed "–whereabouts– I can assure you I don't know where he is buried." His voice sounded a little perplexed and annoyed. "You might check the Chronicle's obituary," he continued "but surely you've done that already."

This last phrase was offered up in his most professorly voice of admonition. "OK," he concluded. "Goodbye." I just stood there unable to process anything he had just said. I grabbed a jacket and walked the two blocks down my hill to the public library and began the process of looking up David Miller. It proved no small task as there were a number of David Millers and then there were a number of articles about my David Miller to wade through: academic awards, articles by, but suddenly without quarter, cold, immovable, there it was: Miller's obituary complete with matching details: his profession, late marriage to Wentworth, his sudden death due to heart failure on the 3rd of February, 1988.

Somehow I managed to return home I do not now remember the walk. My dinner that night tasted foul. I slept irregularly; waking sometime after two a.m. with my right arm completely asleep. I awoke and the day began as the previous but I felt hollow and confused. The closest I can come to a description is a moment from high-school when my girlfriend suddenly broke-up with me by sending her sister to answer the door (this after a very romantic evening the previous night I might add), whereupon she pronounced me a "hypocrite" whom her sister no longer wanted to see: And without further explanation I was sent on my way.

This was three months ago now and I have not until this

moment told anyone any of this story and it is with more than a little trepidation that I record its details here.

Strange things happen. That is not the problem. The strange and the unexplainable reside in their own realm where-in they generally complete themselves. It is the normal, the daily living of the normal that gives us trouble: And when the normal goes strange like a half-gallon of milk well within its shelf date that turns sour; it leaves a certain taste in the mouth and a notable hesitation the next time the carton is grabbed from the refrigerator.

My thought then is this: If I swallow my own story will I not begin to wonder what the process of Memory, as recorded here on these pages, may spawn. Which is to say that I can imagine, as just now in writing the word *imagine,* I have, a woman in her mid-forties, tall, thin, red-hair with hint of gray, short plaid skirt white tunic top, sandals, walking along the curve of a road toward a farm-stand which has wonderful organic fruits and some of the finest sourdough breads I can remember tasting.
She looked up from her stride and saw a man walking toward her. He in turn recognized her as the clerk from his local gro-

cery store: He always chose her line for the talk and banter: the gentle flirt.

"Well if it isn't my Mr. Miller," she said greeting him. "Ah, Kit," he returned. His tone caught her off guard. It attracted her. It made her feel thought of. They talked. They continued to talk. She agreed to his suggestion of "lunch 11:30 sharp." That gave her an hour.

The sun was high enough above the dense row of eucalyptus and Monterey Pines to warm her as she walked. She purchased a small jar of Tupelo Honey as a gift and a statement. David Miller returned to his old farm house, which stood on an acre or so just up the road, where the freeway ramp is now, to prepare their lunch. An hour later he made tea: a small earthenware pot of real or lime flower; what in the stores is sold as Linden. Arriving, she walked past a large lemon tree that was still bowed beneath the weight of its ample yellow fruit and climbed up the three wooden steps that brought her to his small front porch. Through the screen door which was open to the cool April air she could see the edge of a black wood-stove that was quietly swirling with a gentle flame within its glass door. On the table a thick tea pot, deep green short slightly broader than most from which a steady stream of steam wafted into the mixed light of the room's air, sat silently. Two small round handle-less cups waited on a bamboo mat. "Mr. Miller?" she called. "Come on in," he called back. The screen door squeaked and then shut with a defiant "kunk" behind her. She caught sight of herself in a large

intricately carved mirror which hung in the foyer. She stood for a full minute staring into her reflection. She quickly adjusted her hair and caught an open button which she closed almost without thought with her left hand. She noticed a new hint of gray creeping across what had once been lush unique red.

She thought of her friend Mary Lou: Over the weekend she had gone to a small gathering of other friends and acquaintances for a scattering of her ashes. It was a house by the bay. The son-in-law of Mary Lou's best friend and his daughter had made small Japanese boats from white paper, 26 of them to be exact. They filled each with a portion of her ashes. She had quietly extended her index finger into the boat and touched the ash before joining the others in launching it out onto the cold water of the bay. The entire armada had hugged the shore for near an hour after each had been launched but just as she was about to leave one of the children had called out "our boats are sailing." Slowly in gentle bobs and dips while no one was watching they had begun their journey. A few had surged ahead of the rest and had already, owing to their small size, become difficult to find again as they moved, unsteady, fanning out as they did across the water of the open bay. "Hey are you there?" his voice, breaking her thoughts, asked from the kitchen. She looked again at her reflection and then again.

"Yes of course," she said. "I'll be right in."

2

**THE ILLUSION OF PERSPECTIVE
THE ILLUSION OF DISTANCE
THE REALITY OF REFLECTION
AUTOGRAPH

*"FROM THE BRIDGE THE WATER
AND FROM THE WATER THE BRIDGE ANEW"*
walter skanlan

ON A SUNDAY AFTERNOON IN 1988, alone again and as always for the first time, I decided to get myself out of the house for an afternoon. Everything in my spirit warned me not to do this: Between the bus ride and the subway, I knew, I relentlessly told myself, that the sense which I was seeking to extinguish, would only be brought into an acute relief: Just as drinking water after something spicy has been inadvertently consumed is far more likely to focus the intensity of the heat, rather than to relieve it.

In the paper that morning, in the *THIS DAY IN HISTORY* section (it being February Third, 1988 [Gertrude Stein's birthday it duly noted]), the quote at the bottom stated "*and from the small the large*—Heraclitus: The Cosmic Fragments."

The world speaks. I have known this since high-school in Alameda where our Teachers, Fran Claggett and Madge Holland, actually allowed us to discover it, and then simply took our discovery seriously while divinely encouraging us to continue listening.

I still do: When I don't, as on February Third 1988, I tend to find myself at best off course: at the far end of the spectrum—in trouble.

A bus ride, a train ride and a walk through a host of beautiful women who took no notice of me, brought me to The Owl Book Store on the corner of Maxwell and Linden Streets. It was an old store on the second and third floors of one of those 19th Century Victorians which like my grandmother and her family, had survived both the earthquake and escaped the fires of 1906.

READING TODAY the sign announced. I took it as a *sign* but I do this all the time: where in my dyslexic heart I heard an instruction that I would be lectured regarding "reading today," I found instead a poetry reading which pleased me more. I entered and made my way up past self help past business through foreign language up again through mythology until turning I found

the reading area snuggled up next to a quiet cafe with small round wooden tables that rocked precariously.

There was an odd assembly of more than twenty people, all rather fashionably dressed, who seemed to know one-another and who also quickly departed immediately after the first poet read: This left the second reader with an audience of seven, maybe five. That poet, a young woman with short-cropt brown hair and a shorter brown skirt with heavy rainbow colored leggings and divinely awkward brown ankle high boots decorated with sanguine drawings of vines and leaves; wrote in strange awkward images of her life in a fashion which allowed one's mind to relax just long enough so that the assumption of a mundane poem would emerge at which point she would literally twist, her cheek rising and eye closing as if something had been thrown toward it, a word or two would collide into a sentence or image in which they would never beneath the skill of a lesser hand belong: and just as the shock of their arrival would wane she would abruptly end the poem, more often than not with a rhyme that would have been terminally predictable had it not been for the previously jarring turn. After she had read two or three of these, three more people departed, including the most alarmingly lovely woman I had ever seen, who stood facing the poet as she read and slowly pulled on her coat and buttoned it with a defiant intention, then placed her hat on her head (a deep scarlet colored beret), all the while staring at the reader, who in turn ignored her.

The first poet was a tall entirely too good looking doctor or at least soon to be doctor. I cannot for the life of me remember his name. He read a poem about the artist who invented perspective, which given the general standardized condition of his other poems was no doubt called, (at best) "The Invention of Perspective" (and whose first line was of course *"when Lorenzo invented perspective he..."*—but I digress). This at least in its personification of Perspective would have offered the ambiguously lovely possibility that the subject was Perspective's Invention: but most likely that is my own memory and the real title was "Inventing Perspective." At any rate, in the would-be-doctor's poem, the artist, having worked everything out mathematically, set his grid and proceeded to compose the first truly rendered perspective painting; (a landscape with buildings and several alchemical references). He arose the following morning and returned to his studio where he stood for some time in the spare early light of that January day before extending his arm and with his index finger outstretched he traced across the paint to the exact spot, the center from which all the relative balance and illusion of perspective flowed. Turning he picked up a short sharp knife and plunged it into the spot he still held his finger against, cutting around the circumference of his finger, the razor-sharp blade passing so close to his skin that he could detect its cold. He then removed a tiny circle of canvas and peered through. This accomplished, in a marvelous

gesture, he walked slowly around the canvas to its bare back-side and placed his face near the cloth. He adjusted himself, moving up and down left to right and back until the center of his eye came again upon that exact spot which he had opened. With a deep breath, with just the hint of an excited quiver as he exhaled he looked back out into the world from which he painted. Following this he placed a mirror directly in front of the painting which reflected not only the canvas but the room surrounding it as well: Peering through the hole again from the back side of the painting he found that the room and the image on the canvas were indistinguishable.

The thought of this gesture instructs me frequently.

But it is not the picture nor in fact the painting, nor the obvi-ously lovely flight of imagination that moves me. It is the walk, those brief moments of his walk from the front to the back; the lean to the canvas; the search for the hole; that is what interests me. But of the utmost importance is the rejection of every thought and feeling, every voice in his head that told him that his short journey was lame futile or simply silly: *That* is what sets my imagination to alert.

(The remainder of his twenty minutes (and most likely 15 poems) was an exercise in the mundane, called into relief by being preciously elevated beyond everything else i.e. *"my grand-mother, who saw/ into the world with the eye of a hummingbird/ and moved as quick/always got up early and/ could catch up a morning's light/and in describing it to me/ kindle its warmth/*

in the near dead/ school-crushed/ place of my imagination," etc
ad nauseam.)

Randle Farthing knew the same story. He had been to the
same reading heard the same poet/doctor as I had: had in fact
hooked up with the young woman who read second; dated her
for a month or two, allowed her to move into his apartment in
Oakland and promptly broke things off when he discovered
that she had simultaneously begun a relationship with the coat-
woman and thought nothing of it. "She actually asked me," he
told me over a beer two months later, "'How does this affect
you?' That's what she said: 'What has this taken away from our
relationship?' Dear god, I mean David, dear god."
But Randle Farthing hated the invention of perspective. He
hated the doctor, he hated the artist and above all else he hated
the "pretense" as he so often put it "of anyone being so stupid
or pretentious or both as to find anything instructive in such
a pretentious story."

He had grown up in a suburb north of Boston in a first gen-
eration working class family. Tall, physical, light skinned, dark
hair, brooding, intelligent, with clear green eyes that seemed
always to claim you long before your arrival before him; he was
of that class of late 20th century americans who had seemingly
become dislocated from their roots and felt both joy and per-
petual guilt for having done so.

In other words, his life was american: One of those easy stories told again and again by writers for magazines newspapers and trade publishers. What made his story different was the introduction of the poetic.

Somehow he had found poetry I do not quite understand how or why, although I have my theories; but his life changed, drawing him ever farther away from the very world that produced him; this even as he turned toward the complexities of that world for inspiration.

But as always the World tends to keep her balance. The farther into poetry he delved, the farther from his immigrant roots he grew, the more desperately alone he became, the more fulfilled his mind the more aware of something missing that could not be named let alone replaced. The result of this was a growing antagonism toward the very feelings that had blossomed within him. By proportion the more he felt, the clearer he saw the workings of the world emerging from a sound that became a phrase and then a line or two then three or twenty, until a subject emerged one way or another all bubbling out of something he heard; the more broodingly angry he became.

He produced several books: Three volumes of poetry, the most recent, published by a large trade house in New York, was a novel (which gained a quiet following); and a play, produced by a small theater company operating out of the O'Neill House in the east-bay, (which was actually reviewed in the east by the Boston Globe, [although the Globe, which has of course

ignored its native son in favor of the corporate New York main stream, maintained its entrenched position of contemporary blindness by failing to note Farthing's origins in the Hub or even Farthing himself: "The play," they wrote, "the Journey-work of a local poet, was produced by candle light in the barn," etc. The "review" of course appeared in the travel section at the end of a story about Oakland]).

He wrote a number of wonderfully insightful essays on his contemporaries and immediate predecessors, and numerous reviews, all with a keen learned, (yet never overbearing or collegiate) sense of the past.

But as his body of work grew his steadfast refusal to discuss it or any aspect of art for that matter, over dinner or drinks or even in private, grew to have an equal presence in his life. (The one curious exception to what was nothing less than a RULE, was the telephone where one could from time to time have deep rich conversations about what he was trying to do or what he was reading. Yet these talks never failed to end with his dismissal of everything which had just moments earlier been masterfully, humbly and with unnerving insight, delivered: And this dismissal itself would be said in a tone and with such derision that one felt accused of a betrayal for having listened to him with an attention and care equal to that of his own.)

He perpetually played for me and other guests at his home, a jazz recording, Charlie Parker if I recall, where the cut

Parker is recording is stopped after a stunning beginning and the voice of the engineer is heard asking "Can you do that again" to which Parker replies with a joyful and incredulous "No".

Ultimately Randle Farthing emerged into a landscape where appreciation and avocation were pursued without the possibility of discussion or acknowledgment which bordered upon denial. Poetry was not allowed in his social world: Indeed while the house was full of books and paintings they were not and more importantly could not be discussed.

To describe the effect upon me when visiting his home for dinner, I would employ a Walter Matthau movie as an instructive image. In the film Matthau's character is caught by his wife in a hotel room, in bed with another woman. The discovery is without the remote possibility of ambiguity or any other wiggle room for the cheating spouse. Faced with this most profound of absolutes wherein all life as Matthau's character knows it is on the verge of unrequited end and with all the ramifications that will flow from that event; humiliation, divorce and most importantly financial ruin, Matthau in a moment of pure despair– lies. He says as flatly as is humanly possible "But dear, what woman?"; this while the blond mistress is still lying there beside him in the bed. The wife is of course flabbergasted, "That woman right there next to you," she responds to his denial. "How could I lie to you about a woman sitting

right next to me," he retorts. This catches the wife so off guard that she has no answer. "I couldn't. That's the answer," he says as he begins to dress. "But it is great to have you back early dear," he says, before giving her a peck on the cheek: And with that he is home free.

In short then; if a stranger or even myself dared to ask him what he was working on he would invariably say "another beer." If as on one occasion when a young poet from the east coast persisted in her questions, he sent her packing into the other room: "for god-sakes," he yelled, "go have a goddamn life." Surrounded by art, books and artists, constantly rising early in the morning to get in a few extra minutes of writing time, he steadfastly attempted to move through its world as if none of it were going on.

I actually met Farthing at a second reading that week, recognizing him from the bookstore, where he had been sitting near me. "Do you know these poets," I asked him referring to the evening's readers, BethAnn Whitcome and Charles Glassly. "No" was his short pronouncement and I left it at that. Whitcome, with whom I had a nodding-relationship, had read her "poems inspired by the letters between Emily Dickinson and Susan Gilbert, "which," she said, "if read as poems" (ED's letters that is) "revealed a sub conversation/lament regarding Austin Dickinson's affair with Mable Todd." Whitcome's poems then were

as she so acutely put it "the voices of the letters attempting to present themselves through me."

I caught up on several letters of my own and counted the number of pieces involved in the make-up of the complex and ancient inlaid wood floors that decorated the studio where the reading took place.

Glassly, a strong writer, had followed her, reading for over forty-five minutes, making his way across a suite of convoluted images that soared at times but too often left me wondering in a manner not in the least intriguing. He then followed this with, as he put it, "one more poem: a translation of Jalabiense, the Iranian master, who wrote only in French and then himself translated (crudely Glassly claimed) the poems into English; this to protest the murder of his wife, mother, and young son at the hands of the old Government." He then proceeded to read (for another forty minutes) Jalabiense's DEATH SONGS: "*It remains/ strange to me that they/ sent your eyes/ home to me to command my silence/ not knowing that a father's voice/ stands always in the clear-sight of his son*" the forty-five minutes cheerily began, following which all of us emerged from the poem and so the reading in a state that was beyond numb.

This was to me a double atrocity as I was not only bored beyond silly but I knew the work of Jalabiense, knew of his sad life and knew beyond argument that these poems while no doubt deeply felt, were to the truly remarkable body of work which Jalabiense had produced over his long life what drunken philosophical

argument was to a grand conversation taken up over the years by dear friends who could without hesitation return to it at will. He had been twenty-two when those awful events had savaged him; yet he lived to the age of eighty-eight and at some point allowed the percussive beat of this nightmare to support rather than lead his thoughts and vision. A Vision which in-turn became singular. His most lovely book, issued for his sixty-ninth birthday, THE LEFT SIDE OF THE SERPENT'S TONGUE LYRIC APPARITIONS & THROATSONGS, [PARIS, 1928], was and remains for me one of those breath-taking illuminations into possibilities that come along far too infrequently:

i

Still trembling in the flowering
garden where winter's empty fingerprints remain
in the mute scattering of birds,
I search for seed and collect only a stone
small round and black-grayed by Time
which into my pocket as easily as a thought to mind
disappears to be carried away and found
whenever I reach for something else again.

At the point where Glassly had announced the "last poem" and its "inspiration," Farthing had leaned over and muttered "if only they had killed *this* guy"; and his fingers, rising from hands that seemed pinned and hinged to the table, had reached expanded and trembled in the air. "Or maybe I could beg them

to kill me . . ." he whispered upon which he expelled in a soft ahhhhhhhhh, a lung full of exasperated air. Glassly plunged on.

When the reading had ended we had flashed each other a look of disdain for what had occurred and this led to a nod and laugh outside as we were escaping. "How could these two do this to us," he had proclaimed openly to me, at the same time offering me his hand and introducing himself. "Let's talk about something real." "How about" I said, "that Jalabiense is a remarkable poet and this guy just murdered his memory. . . ." "Then it's settled we call in a poetry hit," he said. "Done," I responded. He then replied, "Can I buy you a beer?" I accepted and we spent the next hour trashing Glassly before moving on to argue the merits of the Perspective doctor.

"I mean," he said, "I am not at all sure that this perspective BS isn't something that was foisted upon us by some pre-renaissance precursor to some workshop academic crap-head which has nothing to do with art at all . . . after all it is just measuring isn't it?": And with this he sat looking as if he had stepped squarely upon a profundity.

"Actually," I disagreed, "I think art **is** measuring, one way or another but always—" "Nonsense," he interrupted. From this moment on any pretense between us had ended and he continued (as indeed he still does) to take grand delight in telling me bluntly whenever he thinks I am full of crap; which is often. This conversation proved of course to be uniquely discrete.

He became for me one of the most curious amalgams of thought I have ever met, to say the least. A proponent of intellectual freedom and individual autonomy, he nonetheless railed regularly against the recipients of affirmative action; or as he referred to them, "the elect." "Let's face it she *is* a woman or he *is* black, otherwise 'they' wouldn't be in a position like that," (most often an academic job of some kind,) was a regular complaint. This of course firmly rejected any notion of social responsibility or sense of history on his part which I always found strange, for in his reading, at least as evidenced by his library, as in his own work he could be one of the most keenly sensitive readers I have ever encountered: Each year he has opened his heart a bit more allowed his soul a little breath and at once this has propelled his own work out of the general and into that most specific of utterance which like mercury mutely explodes when touch is attempted, carrying the eye into the numerous. As contradictory as this sounds it was a package which in its own way "made sense."

"Academic" in general was a pejorative accusation, regardless of the context, and yet as I came to know him in a broader sense, he was perpetually applying for this or that teaching job so that he too, as he put it, could be "sucking off the academic tit."

Our relationship developed: an occasional phone call, a beer after a reading, a chance meeting walking in the neighborhood or a short walk for a quick visit to his small third floor apart-

ment next to the park. Nothing fancy, yet somehow it became for me like touching base; no matter what I did, or how far it took me or how closed up in the house I had been, at the end of each cycle, I took up the habit and so the need of filling him in on whatever it was that was going on.

By the end of May, a series of readings and events had made him a firm part of my daily living. We had spoken and planned daily, more plotted, our mutual appearances and like two old men had begun each day by calling each other to go over the atrocities of the previous evening's activities.

Things, which is to say my activities, were swirling along in a way I seldom experienced. Each day was full of people and responsibilities and each day I now see was more and more unlike any day I had allowed my life to become.

My older brother Gerald had died when I was sixteen. It was one of those sudden things; medical; explainable; untreatable. There had been no questions about catching it early or catching it at all. There could be then no recriminations or regrets to divert us from the general fact of his life, sickness and death. It just happened: On Monday he had been in the mountains where he felt light headed enough to get him off the climb which he had planned for months with his climbing partner

Less Choy. He came home went to bed and two days later asked my mother to take him to a doctor. The doctor had been perplexed enough to check him into the hospital that afternoon, although he never shared with us why. "I just had a feeling" he said.

By Friday there was a coma and on Sunday morning he had passed away quietly while I was down the hall talking to Carol Lebervou, a girl from my high-school who had been admitted for a nasty case of mono (which 2/3's of our class proceeded to contract). I walked back into the room and he was gone. I still remember the empty feeling and the alarm it had caused. The nurse asking me to leave. The call to my parents. But what shook me the most I think was how soon the normal began to return. The only emotion of that afternoon came when my mother almost under her breath said, "and then there were three," no more no less no tears. Before long everything was the same except me; at least that is what I felt: There were the perfunctory expressions of sympathy as I returned to each class. But other than that life just re-asserted itself and suddenly I was walking to school alone each morning through the early spring fog listening to the sea-gulls and hoping not to run into anyone let alone someone I knew.

The more time passed the more things "righted" themselves the more alarmed I felt: This particular state continued right into college and into my assuming my life and an apartment of my own and indeed continues to this day. But in the month of

May of 1988 I had relaxed my grip a bit. I had allowed Randle Farthing into my life and life had moved from comfortable warmth to a quickening simmer within a very short time and I was loving the feeling. "The wheel turns" I remember thinking—quoting LeGuin to myself.

The phone rang late in the day of an early warm day and it was an unfamiliar voice a formal voice a voice of authority that I was greeted by: "Is this David Leering," I was asked and I affirmed the fact; such authority as I heard being strong enough to keep me from hanging up the phone on the assumption that I was being solicited for yet another vacation in Florida. Suddenly I was confronted seemingly from out of nowhere with the voice of my mother: "David?" she was saying & it was "Yeah, Mom," I was replying "what's wrong—" "David," she repeated, "we've lost your father..." which seemed to me so odd that for a moment I did not in the least understand until she began the litany of coming home and finding him on the kitchen floor and so on. Five minutes later I was sitting in a chair—the quiet of my house engulfing me as surely as quicksand.

I called Farthing, I could at that moment think of nothing else to do and had to do something. He instructed me to come to his apartment immediately.

The afternoon sun was too warm and there was a slight breeze blowing air that was cold and out of place. Memories would

swell and flood as I walked until I would find that I had stopped
and was just standing: Small things; the back of his hand as he
sat– his arm around my small body reading to me. His voice on
my answering machine, the feeling whenever one of his post-
cards would arrive from where ever he had been assigned– sheer
delight returning to my room like a squirrel with a treasure to
read it– "*the blow hole*" mysterious and Hawaiian– an *island*
and how desperately I wanted to be on an island; standing
next to him when we would go "home" to Napa– he would be
attempting to fix something on the aging ranch my grand-
mother still lived on; our silence as we sat –out back– as we
called it– on a small hill at her ranch "hunting" squirrels–
which really meant just sitting together; the very drive up there,
the cold of my grandmother's house, his voice from the kitchen
in the morning; his ruby ring actually a garnet which he always
wore (which I am wearing now); taking his flying helmets cloth
with ear phones from a box in the garage and flying around
the neighborhood on my balloon-tired schwinn, playing-cards
in the spokes carrying me higher and higher until fuel would
require a quick coasting/engineless landing.

David? I heard Farthing saying "David?. . . are you coming up."
I was I did and for the next hour I sat stunned sipping lemon
tea and a huge grappa he had poured me until it was simply
time to go. "Go bury your father," he had said when he embraced
me "and call me when you get home."

I remember little about the next week or two: arrangements,

funeral, sitting through the Marines playing taps and slowly folding the flag to present to my mother; her silent hesitation before taking it. I had gone over to the ranch and walked the dry creek-bed until I found just the right stone, small volcanic, and a cutting of California Laurel, both of which I slipped into my father's coffin the morning of the Funeral.

I do remember waiting wondering if my mother would at some point proclaim... "and then there were two": She did not.

Before I left my mother collapsed and spent a week in the hospital herself. I pruned roses in the garden for another week and before I could breathe normally again I was back home.

For some reason I could not call Farthing when I got home. He called and left a message or two which I ignored. He stopped-by several times in fact and I did not answer the door. I did not go out except to go to my three nights of work and the grocery store. The rest of the time I spent watching very very bad TV. I wrote little if not at all & certainly nothing which I saved.

July and the heat arrived and I imagined myself living again in the Sonora desert where the sun would be avoided until late in the day, the house closed up to retain the cool evening air. I gardened in the early evenings for several weeks and finally with August and the real heat coming on I went one day to a matinee - a showing of Polanski's Chinatown, out at the Surf theater.

It was the first overt attempt at pleasure I had attempted since May.

A day turned into a week turned into three which unraveled into Time.

○ ○ ○

A horn honked obnoxiously from behind me. I do not know how long I had been sitting at the corner of Coombsville road just past the A&W Root-beer, but the horn was not gentle and was quickly and firmly repeated. All of what I have just written here had coursed my mind in a matter of seconds. The thought of my father made sense, the dream the previous night of him and my grandmother at the ranch had been clear and pene-trating and still lingered in my cells; culled further by the cold December air. When I had left Estelle Wentworth's house in St. Helena I had no thought other than to return directly to my own: yet here I was. The woman behind me hit the horn for the third time and I jumped at the realization that I had not really been conscious when I thought I was and had continued to sit there. I pulled forward but the oncoming traffic held up my left turn and she pulled around me. I gave a guilty wave of apology and she flipped me off before speeding away through the changing light.

I sat there at the intersection the desire to make the drive up to the ranch sweet&sour in my thoughts. The lights changed.

I hesitated. I looked at the small red stone sitting on my dashboard and made the turn and headed east toward my Grandmother's former house.

Coombsville road is thin and winds east across what is now becoming vineyard again. A smattering of tract houses from the fifties, a cluster here or there of development, old farm houses, the Tulocay Cemetery which holds a notable portion of my family, a middle school and just past the corner of Third Avenue on the edge of a hill off to the right of the road, a small red one-room school-house now turned respectfully into a residence, which my father attended until high-school.

I made the second left onto Third; the memory of the excitement that would fill me when ever my mother, father and I would be "coming home" to visit, as this turn marked the end of the endless journey, swelling into me and filling me once again.

A right put me onto East Third, in essence my grandmother's drive-way in my childhood mind: its long straight road is lined with trees and old rock walls, which like their New England counterparts are the product of field clearing. But because of the volcanic nature of the stone and the Italian nature in the hands that stacked them their quality seems always to me

connected to the earth upon which they are stacked in a quiet deliberate way: perhaps it is that these rocks unlike their New England descendants are still raw, unkempt by glacial polish or trimmed by time.

My father would remark the names of each of the road's inhabitants, noting the condition of things, improvements, diminishments, always happy to see one of the neighbors, men and women out working in their yards or coming in from a field, each of whom had known him as a child, had known him when he left for the Pacific and the second of the World Wars, and of course had not known him when he returned and ever less now whenever he returned home and yet continued to greet him with what remains to me today as an elegant tenderness which more and more marks a specific nature in that generation.

The car at a slow canter we would skim past the driveway of his god-parents' house, whom we would visit the next day just after lunch. Then after slowing or a brief stop where the road formed a T, going left up the valley or right into the foothills toward the upper end of our property and the lower end of my great uncle's, we would stay straight and cross starting up the actual drive, my grandmother's house now in view. From her kitchen she would always see us coming and so after we had turned one last time and climbed the steep hill to the top of her drive behind the house she would be standing at the back door, if the weather were good or just inside in winter; the cackle of

voices in greeting the endless hugs the lure of the old barn the romance of the tall isolate tank-house whose first floor housed her preserves and the remnants of my grandfather's wine, (long gone sour) and whose upper floor I would nest in during the summer of 1968– its walls filled with bees which I could hear in the mornings as I awoke; all filling me.

On these mornings I always awoke early and on the cold days which meant that it was Christmas time I would be given a hot cup of cocoa always Ghirardelli and which for some reason never dissolved the way it does now– which always makes me suspicious. I would sit next to my father on a vinyl-covered wood box, which kept the kindling for the kitchen stove, happy to just listen to the two of them talking and talking in a marvelous dance of stories.

But instead of continuing up her drive I turned and drove up the road toward my great uncle's house which sat further up into the foot-hills, nestled amongst huge eucalyptus trees at the end of a slow curving drive-way lined with fruit trees. What had been the entrance to his drive-way was now gated so I maneuvered the car on the small road and turned back. I went only a short distance before a deer bounded across the road onto the upper end of my grandmother's property causing me to stop the already slow moving car. I followed the doe across the marshy area near the road and up the hill where before reaching the top she turned to the right and followed its

contour, trotting now, following a path in the wet green winter grass until disappearing into the oak and manzanita that filled the far side, which was where the creek, rich and full at this time of year, ran through the property.

From this perspective to my right I could see the original part of the home built by my great-uncle, his huge pond, (which he also built himself) stocked with fish which he fed stale bread to; I could follow the slope of the hill down and across the small valley that separated the two properties & back up the hill where my mother and father always planned to build a home yet wisely never did; to the redwood tree tall and spindly being a mere 60 years old, planted by my father in his teens behind the barn, which was still standing as well, with the original farm house crouched into the hill jutting out to its left its front bay window, originally a porch which, when enclosed, became the bedroom of my great-grand-parents which looked down as I now did onto the cold field of the front pasture.

Nothing seemed to be missing or out of place. The gray morning fog showed signs of lifting; visibly moving in places, still clipping the tops of the scrub oaks and pines in others. A hawk of some kind swooped down the hillside in the distance before me, scattering a flock of sparrows. Had my grandmother stood up from her weeding or my father walked slowly into this scene it would not have been surprising: I could smell the sweat from the kerchief that he perpetually wore about his neck; could

hear my grandmother's always when I was a teen annoyingly melodic "woo-whooo" whenever she wanted either of us for something.

I sat for a few more moments in the still barely rolling car. I picked the stone off the dashboard and quickly kissing it rolled down the passenger side window and dramatically tossed it toward the pasture beneath my parents' hill. It hit one of the old fence posts and ricocheted back toward me. I couldn't see where it landed.

The air the fog the hills and house were nothing in that moment but future. I too departed. Pausing only to check for oncoming traffic when I again reached the turn at East Third Avenue.

◦ ◦ ◦

When I arrived home from St. Helena, nothing looked different. Indeed if someone had placed a sign on my door stating "FIG. 1: SAME" it would not have been out of place.

I rambled for the morning. At some point the phone rang and I turned off the answering machine before it could pick-up. The phone continued past six rings so I turned it off as well and didn't plug it back in until the next day.

Despite his storming back into my thoughts, I did not call Farthing. I had not spoken with him in a number of years. I still haven't.

Perhaps? no I am being polite, it *is* simply that he is not part of

"the same"; and his disruption, the simple fact of his being, felt as if it would push me, perhaps silently kicking and screaming, but none-the-less borne, into that thin water where when you look down the future pearls around your ankles: but honestly I don't know. Part of me and only a part wishes that I did.

As I looked back yet again it seemed–or rather– it *was* that Farthing had come (and as I write I realize in some sense stayed on) to guide me to this place where-in everything was after...or before.

3

***THE REALITY OF REFLECTION
THE ILLUSION OF DISTANCE
THE ILLUSION OF PERSPECTIVE
AUTOGRAPH

IT WAS SOMETHING IN PROUST: Something he came across over the course of his first reading of the great seven-volume work one winter late in this soon closing century, that set Maxwell Klopt upon a journey he could not return from.

Whether it was something in the cranial folds of Proust's narrative or something he saw revealed by one of the hundreds of the more modest of the stories that flow like small clear streams through the forests of the central chronicle of *A REMEMBRANCE OF THINGS PAST*; or some image, event or sequence of events; or perhaps it was simply the soft laid-paper used for the original american printing in 1922; what ever it in fact was which so penetrated his being that nothing was nor could ever be the same for Maxwell Klopt; we will likely never know.

What is known, what is certain (and these two elements rarely tread upon one-another), is that sometime in October of 1993, the 23rd to be exact, Maxwell Klopt inscribed his initials upon that thick paper on the rear fly-leaf of a copy of the aging first volume of the American edition of *Remembrance*, published by Henry Holt, New York in 1922: The straight line of the "K" sliced cleanly through the descending "v" of the M to form that near medieval character which those of us who have followed the illusion of progress that surrounds the narrative of these events, have come to know so well.

He repeated this action eleven more times as each successive volume or pair of volumes of *Remembrance* was found, purchased and traversed. He managed somehow to collect the entire set on or before Thursday the 28th of November.

By December 18th he had cleared the first volume, inscribing the date, time and the words "first reading" on the loose rear backboard. By Christmas he was, presumably, well into *Within a Budding Grove* and by January 7th he wrote: "with momentarily heavy snow outside finished this a.m." (In addition to his home on the lagoons of Alameda, he kept a small house high on the slopes of Mt. Diablo, (or at least high enough for as much of the Bay Area's occasional snow as possible), which he used as a get-away and writing studio.): He thus had reached the boundary of Volume Two and was preparing to cross that of the third.

He proceeded through the succeeding books at a similar pace, taking a short break sometime in February to spend a rainy trio

of days at the Asilomar Conference Grounds in Pacific Grove. Following the events of this trip, he wrote a short and rather poignant article, (later published in a special section of the Chronicle Sunday Magazine, with sumptuous nearly mystical photographs by Edward Caldwell), titled: *An Enforced Visit To A Near Miracle:* an article which with long and alarmingly clear mock-Proustian sentences, described a visit to the nesting trees of the Monarch Butterfly in Pacific Grove, California.

It would seem that Klopt was participating in the very idea of vacation against his will. "After all," he writes in *An Enforced Visit*, "what is the use of inhabiting an area with none of the habits and objects which one has artfully assembled available; objects collected with the sole purpose of creating, each day, a life which moves freely within these joyously discovered or carefully chosen objects; objects, which by their very existence, form the boundaries of that life; so that at all points the daily habit of life is continuously made up and played out and reflected upon against the sharp contrast of the absolutely familiar."

He had, apparently, been further coerced into rising before dawn and standing "in a deep growing and near mortal anger, directed solely and with extensive fantasies of malice and mayhem to be inflicted upon the agent of my presence in that cold wet grove of dark trees; which is to say at my dear companion, who had so eagerly placed me beneath a great coast oak where at approximately six-forty-seven in the morning, before the sun had even made its way above the shake roof of the surrounding

house in whose yard, or "grove" as its owner claimed it to be, I was standing; cold, wet, perplexed and relieved of a five dollar admission. At just that point," he continues,

"when my mind had summoned, arranged, reflected upon, refined and was prepared to vigorously deliver an irrefutable argument as to why we must now, without discussion, remove our persons and at a minimum warm ourselves with coffee or the fire in the great room of the lodge or, (and this was my personal preference), return to our little rooms, where from the profound comfort of our cell-like beds we could await the arrival, ever punctual, of 8 a.m. coffee and bread to quickly follow; at that precise moment I was interrupted: And before the thought had coursed from my spleen to my brain and there upon to my mouth, the sun, "*not half-an-hour high*" as Our dear poet wrote, moved its luminous fingers across the rough bark of the coast-oak for the first time that day, where in its wake, just as a ripple from the languid extended finger of a row-boat passenger might leave its own petite wake to the side of the parted water, a line extended, at first thin and then with growing thickness, from which a deep burning orange issued forth from the parting browngray bark with such surprise and inspired specific brilliance that my heart made a quick sprint, catching as it did, my breath and in-turn my amazement. A moment and not a thought later a second such line had occurred followed by a third and

then a number then a myriad, as I realized that everything which I had taken as mere bark was in fact sleeping butterflies. The tree was now engulfed in fluttering washes of color which now attaining the semblance of focus began to further tremble and surge before in a seeming release that was not merely utilitarian but of deep profound necessity, in whose absence the tree would otherwise explode, it let loose its hidden treasure into the air. What began as a few soon (and by soon I mean within seconds) became a hundred and in a moment thousands until it seemed as if some great fairy Spirit long imprisoned was being released from that gentle tree.

We stood for easily twenty minutes or more simply enjoying the AWE of all of this; stood as so many Californians before us have stood, until my Companion, now redeemed, gently suggested that we could depart and enjoy our coffee and fire at length. We left in silence, made the short drive back to Asilomar and completed the journey with a walk across the grounds through the still clinging fog and the deep wet smell of redwood fern and ocean along a path accentuated by long random runners of nasturtium.
After we returned to our rooms we changed our clothing, which was just beyond damp. Apparently between my anger and amazement I had forgotten the pacific fog clinging to us.

We walked back down another winding path avoiding its profusion of nasturtium blooms as best we could while soaking in the smell of fern fog and redwood that was thickened by the now slowly warming air.

The lodge, the design of the architect Morgan in the late Twenties, was as one would expect, warm, rich, cave-like, open and inviting. The fireplace was stone and numerous windows absorbed the ocean filled light from outside.

We passed with a short pause to warm ourselves through this room and after a brief walk entered the dining hall.

We were seated by an amazing maître d' and a young waiter came to us almost at once to offer coffee which we happily took. We then sat, quietly warming ourselves, thoughts fluttering around the vision of the morning and the insatiable sense aroused within me of Time and Place of transience and grace, which now in my thoughts, as I reflect back upon the events of that winter morning, have become fixed; As if so much mutability must of necessity deliver us into the eternity that is California." [reprinted from the *CALIFORNIA LIVING* section of the San Francisco Chronicle]

According to the Fraser Agency in Berkeley, (hired by his old friend Robert Frye), which has apparently done far more work than both the Alameda Police Department and County Sheriff combined; from Pacific Grove Klopt and his companion,

Rosemary Cross, headed south to Big Sur. They lunched over-looking the Pacific at Nepenthe. Klopt notes in his Journal (d 2/23/1:05pm): "Thick fog boiling up the great cliffs from beneath us seeming to cling beneath the canopy of trees. Dense forest smells. Rhododendron wet & redolent with green. Small cup of consommé (double & deeply clear). Small thin slice of lemon floating in bowl sprinkled with nasturtium. The waitress saying that the nasturtiums are notably showy as well as early this year. Lunch of Pacific Halibut on a bed of risotto with corn and cilantro. Rosemary springing for a ½-bottle –none-the-less pricy, of Henry Bourgeois Sancerre, which was delightful and worth the money. Hot Linden tea in a thick near-black-brown-earthenware pot and a small poppy-seed cake for dessert. We were quite pleased."

Strangely, given the volume of events and travel for that year the rest of the journal remained blank.

It was at this point that the first mirror seems to have been purchased. Klopt stumbled across it in a local antique store. In the account given to the Fraser people by the dealer, Charles Farnsworth, owner of Third Eye Antiques near Big Sur, (which specialized in early east-coast furniture) he clearly remembered Klopt as "a guy with a funny coat and with a rather beauti-ful older woman traveling with him." "Klopt had been quietly perusing the store when he came across an old mirror," he continues: "Nice, clean, dated 'Boston 1840'; but not domestic,

imported and already considered antique when it arrived. It came in through Salem and was then sold out of Charles Proctor & Sons on Severance Street who set the 1840 date to it." From there the mirror had somehow passed to Buffalo and hence west, bearing the sales plaque of Oscar Hornscline Esq. Chicago, 1890. It then turned up in LA in the estate of an Estelle Wentworth who worked for Chaplin's production company; and that is where Farnsworth picked it up."

It was of a certain type of mirror which was normally of interest to a select group of collectors who sought not merely the antique but particularly those objects bearing a documentable history as well as a unique iconography. The former I will describe but it is the latter that seems to have lured Maxwell Klopt to his ultimate fate.

"It was a unique piece," Farnsworth's deposition continues, "not only was it well traveled, but it also contained, inscribed over the years upon the back of its frame, a rather complete provenance.

In addition to Estelle Wentworth's name were the names of Ephora Feidt, (the earliest decipherable name), a Boston Mystic who later disappeared in Ipswich and Charles Johnson, a furrier in Buffalo, who was thought to have been murdered by his mistress, Melissa Williams. Williams was a local actress who, despite her initial rather tender relationship with Charles Johnson, seems to have come to despise the fur trade passion-

ately enough to have murdered him and cleanly disposed of the body; which was never found. Johnson had been seen entering his grand Victorian home on Niagara Street on the morning of his disappearance by a detective named Chuck Fuller, who was investigating him in regard to an alleged (but never pursued) stock manipulation. Fuller claimed, under oath, in a deposition whose clandestine release to the press shocked Buffalo social circles in the spring of 1888; that Charles Johnson had entered the residence with Williams on the morning of April 13th and had not emerged that day nor on the succeeding two. Fuller's report to Chief of Police (and his former boss) Ivan Thompson, led then to the "discovery" by the authorities of Johnson's "absence." Because of this and Miss Williams' flimsy claim that she believed that he had made an unannounced business trip by early train to Manhattan; foul play was quickly and widely assumed: Or as the rumor which spread through upper-class parlors put it, with notably less demure, he had been "murdered by his so-called 'live-in friend'." This was a moniker with which the Buffalo papers quickly came to address Miss Williams; at first as an appendage to her whole name, but it quickly replaced even that.

Speculation had been further fueled and stoked by her rather complete lack of cooperation with the investigators. At first she refused to speak with them at all and only reluctantly did she allow them to search the premises on Niagara Street. But by this time nearly ten days had passed. The search, the first of three,

turned up nothing: And each subsequent search, each progressively more intrusive than the last, retrieved more of the same. The only words attributed to Williams during this period were in regard to these searches: "More of the same nothing– that's what they found." This was sarcastically reported on the front page of the Buffalo Sun; large type, well above the fold.

Rumors swirled. The most convoluted and slanderous providing the grounds (such as they were) for one final search (and this nearly fifteen days into the investigation), during which a portion of the cellar was exhumed and an entire knee-wall in the attic dismantled down to its studs.

After this Miss Williams plunged herself into a three month seclusion during which she never left the House. Rumors and press accounts lost appeal and the appetite for them dispersed. Sometime in early July she departed Buffalo, leaving everything behind at the Niagara Street house with the exception of Johnson's dog, Lincoln, and a "finely crafted antique mirror inherited by Williams from an Uncle in Lansing," which was storied to have been her only personal possession aside from the most basic necessities of daily life. (This was reported in one of the many speculative stories regarding her possible motives for the murder and now her own disappearance, which briefly reignited the story.

And that was it. A month after her departure her whereabouts were declared unknown as were that of the dog and the mirror.

The mirror remained unseen until it resurfaced in the collection of Estelle Wentworth sometime in the 1920's. It bore, as the estate inventory records, on the lower left of the rear frame, just below the Charles Proctor & Sons label, the signature of "Ephora Feidt, Boston 1847" and the sales plaque from Chicago, the inscription: CJ/MW Buffalo '88. On the mid section of the right side of the frame, in a square hand, small and unsure it also reads E. Wentworth <cc> 1914.

Wentworth turns up, as does the mirror, in Peter Flannagan's early book on Chaplin; *Lost Reflections: The Production Of An Artist* [Scribner's, 1924], for which he interviewed not only Estelle Wentworth but literally all of the work-a-day folks involved with Chaplin's original production company. *"I want,"* he says in his lovely introduction to the book,

> *"to preserve the Charles Chaplin whom I see working before me each day: That man, tender, delightful and above all else loyal, both to his fellow artists, the practice of his art and to the Idea of Art itself. The man, my daily friend, Charlie to many, (always 'Charles' to myself, (and this my habit, from the day now many years ago, when we first met)), with whom I often sit: As on this very afternoon, we perched on the false stoop of a house facade for near an hour, freely discussing recent events in Europe with camera operator Sam Overstreet (as well as Sam's recently acquired Mexican shoes): A man, plain, near simple, always direct, who works tirelessly to create an elegant art. Yet it is still as it has always been, an art*

which emanates from a man whose greatest quality has been
his absolute connection to and joy with any of us. This is the
'Chaplin' whom I would preserve, before, as will surely occur
soon, this very real man is engulfed by fame or the would-be
chronicles of history writers and thence by Time herself to
become no more than an Image which we call 'Chaplin.'"

Estelle's story proves to be the most interesting: Not only in regard to our narrative, but within the cast assembled for Flannagan's book as well. Although young, she was none-the-less notably more sophisticated than many of the other members of the company, as her family (on her mother's side) was descended from a long line of the Great European Circus Clowns: Jean Claude Louie, René Armagnac and Giovanni Pinoli (a distant cousin and notable Pierrot).

She had grown up in that curious atmosphere of artistic households where the arts and their attending activities were the norm. This made her not merely an employee or even a friend to Chaplin: it elevated her in his eyes to peer and Source at the same time.

In her interview, fluidly guided by Flannigan in January of 1919, (meaning he had questions but actually listened to the answers and allowed the interview to develop its own directives and momentum, which he steadfastly stood aside from); she speaks eloquently and with economy of the "*True and Profound role of the Clown in the structure of the arts*": Rooting Chaplin as

she did to the Renaissance Court and Shakespeare and deftly placing him as the "Court Jester to an emerging sense of the world." It was a magnificent performance, at least as transcribed and edited by Flannigan.

In its final section he asks her (as he did each of those he interviewed) "as a film maker" to describe one scene "short & sweet," which they would choose to shoot and deposit for the visual record. "One scene that might hold for the future the truest image possible of the Charles Chaplin whom you in particular see."

"That would be an easy one," replies Estelle: "I'd call it 'Uncle Paul's Mirror': We were in the hallway to my house which was lit but modestly and had great shadows claiming small but notable areas. He had been with us for most of the day. We took a turn, after a late lunch, into a room with large pocket doors where I had stored some of my Uncle Paul's treasures. Amongst my Uncle's possessions were several of his father's suits and two costumes from his show days. Since their arrival I had wanted an opportunity to dangle the costumes in front of Charlie. He more or less ignored the two of them, which were marvelous and old and in great shape. They possessed that ancient, undiscovered appearance that can be intriguing to some, myself included: Not Charlie. He quietly went crazy for the suits; finally asking if he could try one on. I was perplexed but happy to put them to some good. Not to mention that this avoided the worry of harming the older costumes.

His face which was not quite turned away from me took on, as I offered my approval of him wearing the suit, the look of delight and pleasure that one might see in the face of a quiet, disciplined child who has just been confronted by Christmas morning. I left the room. He changed and emerged into the hall asking as he did if he might borrow the suit for a bit. He walked through two of the deepest shadows and emerged in front of the old carved mirror which had also arrived from Chicago with Uncle Paul's other effects. He stopped short, tilted his head and slightly lifted up his right shoulder once. He noticed one of Ted's hats and reached for it as if it were his and as always there where he left it waiting to be retrieved as he was leaving. 'Might Ted miss this,' he asked even as he reached for it. I told him Ted would be happy to lend it to him. Yet even as I was saying this he already had it on and had returned to the mirror. He just stood there staring into it –didn't say a word."

"It is easy to offer to you that nothing was the same for him following this. It is obvious to all but the daft that he saw something there: and his little man was obviously born there and then, (although there was no mustache of course that would be added later): But when he turned to go, there was something else, something different to be sure; but it was not something found it was something missing. Something of my friend Charlie did not emerge from that mirror. I realize this sounds a little daft itself or melodramatic. Especially so

when you consider all that seems to have flowed from his creation of that man who we watched yesterday. I just don't know. ... But that's what I would film. The turn from the mirror. The Absence."

"And with that," says Flannagan, *"Estelle quietly ended our session. I believe that she was overwhelmed by the memory of what she saw or didn't see. But whatever it was, the tone with which she ended our session was that of loss. As I left her house that afternoon, I took a quick look into that mirror. I saw nothing. Were that it was that I meant that metaphorically: I literally saw nothing. The mirror or I should say its silver, ancient and well tarnished by the years offered up little to no reflection. It was as if Time herself had already stepped between us and worn away the thin film upon which we are reflected."*

After Estelle's death in 1989, Charles Farnsworth had learned from David Morgan and Carmine LaFae (long-time friends and colleagues in the industry, who dealt in rare books and maps from a small shop in Pasadena), that the estate of a long time resident of Los Angeles, a woman with family ties in the east and Europe, as well as to the early film industry had recently passed-away. Farnsworth was deeply excited. He saw her as being one of those lovely passage-ways that, as he put it, "crossed the centuries and allowed all sorts of wonderful things to quietly

move from one time into another. Just imagine her life," he told the investigators, "she was born in the 19th Century, to parents who had been born in the 1870's. Her mother's parents (whom she of course knew as Grand-Parents,) in-turn had immigrated in the late 1860's, arriving in post Civil War New York four years after Lincoln's assassination. It amazes me that as quick as that one can be sitting and chatting with someone whose parents became aware in the 1870's and their parents lived through the effects of the Civil War."

"They lived briefly in Manhattan, then Buffalo and moved west sometime before the turn of the century: And now with a third century on the horizon she had passed away; like someone who arrives at a house only to die at the front door. What drew me," Farnsworth continues, "was the possible accumulation of artifacts from the daily life of such a woman. This of course is why I grabbed her copy of the Chaplin book. I could have cared less about Charlie Chaplin but Flannagan's idea of daily life being important to document intrigued me. I didn't realize until after I had been thumbing the book for some time that it contained the interview with the deceased. So at once it took on a great associational value if I were to purchase any of the other pieces in the estate (which I made darn sure to do). It was signed by the author and that of course made it a little better - although who is Peter Flannigan I would ask you: But slipped into the middle of the volume, on the page just prior to Estelle's interview was a note from Chaplin. Short & sweet. In a small

clear hand it reads simply: "You have not lost us All Love, C."
Well that was it. I selected six fine pieces: The book of course,
which I got for a song (the estate obviously hadn't noticed the
note); a rather fabulous carved love seat –pure California turn-
of-the-century with the original upholstery and wood as clean
and beautifully aged as a babies bottom, you could just feel the
people sitting in it; an early Chagall lithograph- an artist's proof
with notes by the Mourlot printer across the bottom, inscribed
by him (the printer that is) to Estelle's Mother, Maureen; a fine
John Martin mezzotint *"The creation of Light"* from his Bible
suite, in a period frame; an intricately painted metal French
plate warmer from the 1880's, which was made to fit over the
top of a radiator; a sleigh bed- circa 1847, richly patinaed; and
lastly the mirror. I almost missed it as it was wrapped up and
sitting over in a corner of the dining room, surrounded by large
ceramic vases and covered with a hand-made afghan, (which
is what had originally attracted me). It was a great haul for us
and everything sold readily. Everything with the exception of
the mirror. People loved it. They loved the wood, they loved the
carving, and they loved all of the inscribed initials on the back.
But it was the mirror itself that killed it: everybody found it
just a bit too clouded with age to actually make use of. A cou-
ple of people came in and offered me some ludicrous amount
for it; twenty bucks one time. But I thought it was special and
I wouldn't let it go."

"That's why I remember Klopt," he continues, "he was literally

the first customer for whom the quality of the mirror was not an issue. In fact I don't think he even noticed it to tell you the truth. He came into the store, browsed around awhile, and the first thing he did when he noticed the mirror was to use it to check his tie. Then he ran his hand across the wood and finally he just stood there staring into it. He called his companion over and she could have cared less: But he saw something. He asked the price and I told him the history of the mirror first. He asked the price again and I said $800. He offered me five and I took it. He paid and they were out the door: Just like that. I have not seen him since. I did refer another dealer to him but that is all. The next thing– you folks show up asking questions."

There was actually nothing surprising about Klopt noticing the mirror. But given the amount of detail in Farnsworth's narrative it seems odd that he never mentioned the physical design of the mirror: But it was the design that first attracted Klopt's notice; this we can be sure of.

Despite the tarnished and blurred condition of the mirror its 16th century wood was richly burnished from countless hands and remained in fine condition. From both its lower left and right bottom an intricate carving of leaves and branches had been fluidly executed, each respectively flowing either left or right and ascending up the sides. Somewhat up from the bottom edge, maybe a third of the way, from beneath a leaf a small twisting caterpillar was half-in and half-out of a cocoon which

itself hung by the thinnest of threads from a bent branch. This in-turn led the eye at once back across the foliage below (which was so skillfully rendered that it always seemed to be moving as if it were perpetually and ever so gently being raised up by the slightest breath of a wind), where one realized that numerous other cocoons lurked beneath the leaves and twigs as they ascended the frame. Above the first caterpillar another was making his way across a long stem and beyond this a third was stretching up expectantly into the air while just beyond his reach a butterfly emerged from beneath a slightly curled leaf: And from this single remarkably depicted immigrant, a host of butterflies flourished across the vining branches until they erupted into the clear air of the upper frame.

All of this was rendered with the subtlest touch imaginable so that there was not the slightest hint of excess or cliché to the work; and yet it was done with such strength and magical accuracy that the mirror when placed upon any given wall seemed near to being lifted away by the force of itself. Were it to have begun to move and flap it would have been at most a modest surprise.

"We settled on a price," Farnsworth concludes, "and as I was doing the paper work he returned to it and just stood there like a silent douf, staring into the tarnish. We settled up and I took the mirror and wrapped it in brown paper and some packing to protect the edges. But just as they left, just as his friend was again teasing him about buying a mirror that didn't reflect, he

stood in the door-way, tore open a small hole in the wrapping and held it up to her. 'Dear god just look at this,' he said; to which she just laughed and replied, 'Good lord Max let's go.' And that was it. They left and as I said, now here you are."

Klopt and Ms. Cross returned to the Bay Area. Yet it was only a few days following their return that he made his first trip into Abacus, David Degan's little antique store in Oakland– up off of Grand Street in the foothills. He purchased a second mirror from Degan.

The following week he went up to the Napa Valley, this on Degan's suggestion where he visited the home of Mark Townsend out on East Third. Townsend was a serious collector notably voracious in his purchasing, who periodically sold off pieces which had lost their appeal.

Townsend traveled and collected a good deal and he sold Klopt what he described as "a fine colonial painted mirror –late 18th century small and simple," which he had purchased in Newburyport, Massachusetts in the early eighties.

There were other forays: San Francisco, Mendocino, Bodega, Marin and so on, and according to Detective Simmer's count, by mid April he had collected 27 mirrors.

Interspersed with all of this and seemingly without interruption he kept working his way through the Proust one slow volume at a time. As he reached the end of each book that made up each volume, he habitually signed off on it by noting the date

the time and finally the weather followed by his distinctive
MK initial.

On April 13th he made the following note on the rear fly-leaf
of Time Restored:

"Finished this day April 13th 1994 12:55 p.m. after a morning
spent reading and napping. Upon reaching the words *'so widely
separated from one another in Time'* I looked up from my reading
to discover that sometime during the last hour, five or six birds,
finches if my book is correct, with small red markings about the
heads of the males, had very casually perched themselves on
a small chest next to my chair. They had come in through an
open window and were quietly standing or pecking at fugitive
seeds from the feeder outside. Three of them ended up on the
new mirror which I had laid flat on my desk near the window
where they sat pecking at their own reflections. They continued
thus for several minutes until one by one they departed; each
one with a small "peep" as it did. Quiet filling me. This book
carrying me to . . ."

He then closed the slightly loose rear board of The Past Recap-
tured and so the novel itself forever.

As best as can be determined, he closed the book at just about
the same time as his phone rang. Rosemary Cross said she
could tell he was shaken by something. He bluntly stated he

would call later and hung up. When he in-turn finally called her a short time later: "there was a certain tone; nothing so dramatic as a hush or whatever: but it was not normal. All he said, and I mean all– there was no greeting or other pleasantries, –was 'I've finished. I really can't talk. Call me back' and bang he hung up on me. I waited until that evening before I dared call him back."

It was somewhere between these two events, if I may call them such, that Bennett Poindexter from the Owl and Ring Antiquities in Pasadena called him.
Poindexter had been referred to Klopt through Farnsworth. He in turn had been called by Morgan and LaFae who had seen Poindexter's treasure and thought Farnsworth would surely be interested. Farnsworth who was preparing to depart for a long planned vacation in Spain and Portugal and was desperately short of time, then dug out Klopt's phone number and passed it along to Poindexter, noting that Klopt might be just the customer for what sounded to be an extraordinary mirror.

When Klopt answered his phone that afternoon, still wet from Proust, he was more or less rude to Poindexter.
"All I was able to manage," Poindexter recalled, "was 'Bennett Poindexter here,' and I was assaulted by a brisk inquiry as to who had given me his telephone number. I replied using

Farnsworth as a reference. 'Who?' was all I got as a reply. I took a deep breath and the moment of silence calmed Mr. Klopt enough so that his gentility took over and allowed him to listen to me."

"'Forgive my intrusion Mr. Klopt, let me introduce myself' I said: 'My name is Bennett Poindexter. I own Owl and Ring Antiquities here in Pasadena and I was referred to you by Charles Farnsworth up in Big Sur who said that you might be interested in a mirror I just acquired.' Klopt's demeanor changed slightly and he replied asking with noticeable seriousness 'What sort of a Mirror'"

"'Mr. Klopt,' I continued, 'I have just come into possession of The Mirror of the Sixteen Snakes.' This was answered with silence. A silence which continued until I had to ask if he was still there. 'I am,' he replied. 'How did you find it.' 'I didn't find it so to speak as I wasn't actually looking for it. It surfaced last weekend. So you have heard of it. 'I have. What was your name again' he asked and with this everything changed."

"I could barely get a word in. He seemed to be making plans in his head while we spoke. I repeated the information and gave him directions to the store. He thanked me and said that he would get back to me. The next thing I knew he was introducing himself to me while I still sat in my car."

"'The Mirror of the Sixteen Snakes has surfaced': that is what he said when I answered the phone" Cross's deposition continues.

"He wouldn't even tell me what it was or why it was significant. 'I'm going to the Diablo house to close it up and I'll pick you up at six.' That was the extent of what he said."

How Klopt had come across the stories gathered around the Mirror of the Sixteen Snakes is anyone's guess.

The Mirror of the Sixteen Snakes is near as much Legend as it is art, craft or antique.

Long spoken of in those strange elaborate intellectual circles of Northern Europe which emerged in the mid 15th Century, the mirror is first noted to have adorned an English manor house on the Thames, just outside of London. There, it is said to have collected the image of a number of period notables, not the least of whom was a young Elizabeth Tudor, just prior to her coronation in 1558.

It first manifested itself onto ink and paper within the richly decorated covers of the Journals of Prince Albert Laski, on the 9th of September 1583.

"Into My hands and upon My chamber wall The Mirror of the Sixteen now hangs: The completion of near all I have desired. As it took its place amongst the others a great flight of birds vaulted past the near window of my study with such commotion that I was given the thought that they were marking the occasion themselves.

The two Englishmen have not exaggerated their description.

I have made it right.

The Circle closes.
On tomorrow's Eve I shall offer my reflection to its Library…"
[see Volume 33 of the Journals of Albert Laski, Ashmolean Museum Library, V33 L16 CCALCJ0601 (page 90)]

It is this last phrase which has so attached itself to the legend that arose around the Mirror, as it was assumed that from at least the date of Laski's entry, (and not unreasonably, by extension, long before he came into possession of it), that what this statement revealed was the mirror's unique quality: By which I mean to say that it was commonly thought that each person who looked into its glass left behind, forever resident within the finely carved golden square of English walnut, in one fashion or another, their self's reflection. Indeed in some of the more esoteric conclaves it was thought to take the entire being of the person gazing into it.

Sometime late in the 17th century it made its way back into London where it was recorded on an estate inventory which a period scholar recently came across in the Library at Oxford, as having been in the possession of the deceased whom is recorded in the mirror's oral history as "a significant yet little known man of Letters and Science."

It is known to have remained in London until around 1608 when it again disappeared into that other History which Time does daily feed upon without witness.

From this point on it grows rather dim or dark. There is one trail which places it into the home of William and Catherine

Blake: A story which arises from a single passage caught by Thomas Bennett of the North Point Gallery in San Francisco who came across it while reading the Journals of the young John Martin. Martin makes mention of having seen, in the Blake's cottage, *"a mirror whose twining frame could have caused to be issued the call for Adam's expulsion: I know not but that its countenance is such that it may have removed our hosts from the world of men long ago. I paused but briefly before it and then passed on feeling cold and, most oddly, of great appetite when I had done so."*

But it is important to note that this portion of the mirror's provenance is generally considered to be apocryphal.

What is certain, is that its more recent whereabouts are not at all clear until it comes into the possession of a young french country woman, (and just how this occurred is but pure speculation), who lived and worked in Paris, named Céleste Alberet.

After her years in service, such as they were, Alberet had lived out the remainder of her small rich life of association, working in the Musée Rodin where she conducted tours and at times discussed with great charm and clarity her early life in Paris.

Following Alberet's death in 1984 at the age of 92, the mirror, apparently long stored away, was purchased from her estate for the American film critic, Jonathan Nathan, [*Visconti and the New Orders of Time,* (1973) and *Portable Dream: The Unspoken Effect of Film* (1975), the latter of which won warm praise from Chaplin himself who wrote: "Mr. Nathan has, like the most

sincere of our beloved poets, momentarily solidified in Language, that which as a practice stubbornly thwarts even the inference of permanence; here penetrating into the Truest and (aside from Film's most important aspect, the sheer Joy and Pleasure of entertainment), the most profound aim of our art: the creation of Dream."].

cf. interview with Charles Killinsgly for KQED 1976

It would seem that Nathan rather quickly sold it to a stage actor named Edward Kelty, who was one of the numerous regulars over the years, (a near star) in the circles around the Theatricum Botanicum; Will Geer's back-yard Shakespeare Company in Topanga Canyon. Little more than his name is recorded, save for the fact that he resold the mirror to Bennett Poindexter seven months to the day after he purchased it from Nathan for an undisclosed amount.

"He was to-the-minute prompt," continues Rosemary Cross, "which itself was unusual, and he was almost, well– rude. A man to whom manners and minor formalities were like small bouquets gathered from a well tended garden: this same man said 'just get in the car.' He took my bags and we took off. He drove a deep green '72 model Saab. One of the old turtle station wagons built in the early '70's which he maintained with a passion."

"He drove in a silence I didn't dare intrude upon until we reached I-5 and made the turn south. He drove fast pushing that little car to its limits. He didn't even let it rest at the top of the Grapevine."

"After hours of driving he said suddenly 'forgive me, I don't want to lose this opportunity.'"

"'Opportunity for what,' I asked. He looked at me as if I were out of my mind or was so ignorant as to not warrant consideration."

"We drove straight through– made it into the basin in under 7 hours. The fog still clutched at the ground as we descended from the mountains and as we passed through it he turned and said 'You do realize the significance of this piece' 'Well,' I said, 'I most certainly do not.' 'It's the Ouroboros,' he said. 'It completes everything': And with that cryptic little announcement he recited the entirety of the mirror's history. Two minutes into it and I was lost. I mean I had no idea who those people were nor why it mattered that they had owned a mirror. The only thing that made the least bit of sense was the part of the story that claimed that the same man had carved both the Butterfly mirror, which he had purchased in Big Sur when we were down there as well as this 'Mirror of the Sixteen Snakes.'"

"'Sixteen snakes all in a circle: the Ouroboros,' he said as if he were reciting an ancient legend, 'tails in their mouths eternity and return and the butterflies. . . . time and spirit, eternity and

rebirth . . . earth and air and what separates them but time and memory.'"

"I believe Festus Leonard's account in his little book *Deviant Rivers*. He said, 'the two mirrors were carved from the same walnut– the same tree and it is obvious that the artist never intended them to be separated. . . . they were created as reflections of one-another . . . they *are* reflections of one another.'"

"'Just stop for a moment and think it through' he said, just like that out-of-the-blue. I managed an 'O–K' but at that point I was growing more than a little concerned let alone fed-up with what felt to be a manufactured drama."

"I could feel his excitement but to me they were still just mirrors carved and expensive; and in the case of the butterflies– simply too far gone for use."

"He checked us into a Motel 6 in Pasadena: a non-smoking room which had the lingering acrid smell of a generation of cigarettes mixt with perfume.
We both showered and changed clothes and were off again an hour later. I still felt slightly soiled."

"The scene at the antique dealer's was notable," Rosemary Cross continues, "Mr. Poindexter was out for the afternoon and he had left the place in the hands of this– young woman: Pure LA: tall, lanky, poured into a pair of bell-bottoms with horizontal stripes from top to bottom– which only made her look skinnier.

Her shoes were mere slips of leather beneath her feet, with thin straps that left the impression of nudity. She wore a blouse whose material, thin and pale blue, clung to her body revealing every bone, breast and nipple. Her black hair looked as if it had been ironed straight; and while it was no doubt clean it seemed that each piece of it hung with severe individuality. She said nothing as we entered. She subtly extinguished a cigarette like a savvy school-girl, and slowly exhaled the smoke thinking no doubt that we couldn't see her: But in the strange light that filled the Owl and Ring, (all the windows and there were a lot of them, were huge but all oddly low just as the roof was oddly close to ground around its perimeter, (you could touch its edge outside with an extended arm) and yet soared in the center of the building to almost twenty feet); she looked like the Cheshire cat from *Alice*."

"Maxwell wandered the store for a minute before asking for Mr. Poindexter. 'Mr. Poindexter' the girl asked in a tone that was both obnoxious and incredulous at the question. With that Maxwell snapped. 'This *is* the Owl and Ring, isn't it.' The girl just nodded. 'So where the hell is Bennett Poindexter.' Like I said, you have no idea how out of character this outburst is. Maxwell is a large man; a man with presence. A man who has lived with that presence for forty years or so. When he speaks, it sort of holds you . . . the tone of his voice that is and he would never raise his voice. There was a time years ago: We were in a bar and this jerk started trying to pick a fight by claiming that

Maxwell had taken his chair. Maxwell thought nothing of it & was happy to give the idiot his chair. Then the guy says 'What the hell were you trying to pull' and Maxwell looked up at him from the seat which he had just moved to and said 'I **am** sorry.' The guy began to persist in his verbal assault and Maxwell stood slowly, not budging from where his feet had come to rest when he sat down, looked the man straight in the eye and near softly said 'Friend–' and he just let the word dangle for a moment, 'that was a real apology,' and that was it. He just stood there and it caught the fool so off guard that it must have truly scared him. He lost no time in mumbling 'well ok then' and turned quickly to rejoin his friends. Maxwell tended to handle everything like that. No dramas: just startlingly gentle directness."

"So there is this scrawny waif, stinky with nicotine and smoke and this large man who seemed like a great placid lake one moment, roiling the next with anger."

"'Mr. Poindexter went to the Watts Towers with his friend Mariee and her husband who are visiting from up north.'"

"'Where are the Watts Towers' he demanded."

"'Watts?' she answered, which just pissed him off more."

"'Of course they're in Watts,' he faked. He had never heard of the Towers nor had I for that matter."

"'Where is the mirror then?' he demanded."

"'Which one' she intoned. 'He has lots of mirrors.'"

"'The Mirror of the Sixteen Snakes it is very special... surely....'"

"But she cut him off at this point."

"'Anything special is locked up. Mr. Poindexter doesn't let me touch that stuff. Mr. Poindexter says I don't have the hands yet. Mr. Poindexter will be back after five. We close at six. Is there anything else.' All of this had been said without a breath taken which made it annoying even to me."

"'No,' said Maxwell flatly and he turned away as he did. He looked completely deflated. If he had burst into tears I would not have been surprised."

"We returned to the car. 'Now what,' I said."

"'Now we go to the Watts Towers.'"

"'But where are the Watts Towers' I asked and finally his smile returned: 'Turn left at Grant's tomb?' We got into the car and consulted a guide-book."

"The trip down to Watts took twice as long as the distance had led us to calculate. That is the troubling thing about distance: And there is no distance in LA that is near. Anyhow it was near 3:00pm when we arrived in the neighborhood. We got lost which was not really our fault: The directions in the guide book seem to have been written by somebody who could never have actually been there. Finally we turned onto one of those classic So-Cal. streets: long and curving and there at the end, tucked behind the most completely unassuming little ranch house, were the three towers."

"They literally bolted up from the back-yard spiraling into the

air on their sea-shell and soda bottle flying buttresses. It was simply one of the most moving things I have ever seen: good enough to take Maxwell's mind off of Poindexter and the mirror for the first few minutes. As I said I was overwhelmed. The profound simplicity. The quote 'I just wanted to do something big' inscribed on a plaque nailed to the stucco of the house by the city of Los Angeles: this was after Simon Rodia, the man who lived there and built them, disappeared; after the crews had come out and attempted to tear down the tallest of the towers but found them far too sturdy for their feeble efforts: The story that the children in the neighborhood had begun in time to bring Rodia shells and bottles for the construction; the adults throwing rocks and bottles, which Rodia would pick-up and use as well: only deepened the profound feeling which the Place elicited in me. I walked around feeling as if tears would overwhelm me at any moment. It was a little Gaudí, a little Chartres-medieval, & so completely contemporary and most importantly, so completely California. We wandered the yard in silence, which the Towers seemed to request. There were bird-baths and little shrines and places to sit. The air carried the screams and laughs of children from a near-by playground like a distant music. The three towers, the highest of which was over 90 feet high, stood in a deep possession of space which they held around us and above us. They seemed to cast off color into the atmosphere."

"Each time I followed a shell-and-bottle flying buttress up into

the air, my heart soared with my eyes along each ascending line. It was the strangest feeling: It was, I realized, like watching my sister's little daughter Emma at play."

"After about twenty minutes of wonder and looking and silence I noticed that a piece of the pinkish-colored stucco from one of the towers was laying in the dirt just outside the fence that surrounded the yard but still just within my grasp. Without thought I reached through the fence and grabbed it. Maxwell strongly disapproved but I didn't care I wanted a bit of this marvel. I wanted to look at it on my bookshelf when I got home, I wanted to remember: so into my pack it went."

"Suddenly Maxwell approached an older man who had just arrived and inquired to see if he was Poindexter. I could barely hear the conversation but I knew what he was asking. The man was shaking his head no and pointing to the front of the house. Maxwell bolted from the back yard leaving me alone there. When I left the yard and the shadow of the towers (although I have to say that their presence has clung to me like a fine delicate scent; even as I am talking to you I feel their urging: crazy I know but I swear to you that nothing has looked or felt the same since our visit), I went around to the front of the house and found him talking to a man and a woman. I was introduced as I approached. It was indeed Poindexter and his friend; the gentlemen in the court-yard was her husband. Maxwell almost blew everything though by asking who and I quote 'the scrawny post-pubescent bit of fluff running the Owl'

was. Had there been time for an awkward silence it could have poured from the end of this sentence without pause filling the grand canyon and the adjacent deserts without depletion: But without pause Poindexter flatly stated: 'My niece.' There was now a silence of three maybe four seconds before he muttered in a lighthearted manner, '& if there is a god she will grow out of this stage.' This made everyone laugh even Maxwell who was more likely relieved that he hadn't insulted a man with whom he so wished to do business.

"'I am sorry,' said Poindexter, gathering up his laughter, 'I do hope she didn't say anything crude.'"

"'Not at all,' said Maxwell."

"Poindexter told us to meet him at the store at 7pm. We left, stopped off at the hotel and then went for an Arby's Roast Beef sandwich: This was the first normal thing Maxwell had done for days... Arby's being one of his few guilty pleasures which I was aware of: Or at least that he would openly admit to. Whenever we traveled he had to be indulged at least once. I didn't mind: A man as closed to his emotions as Maxwell Klopt could be, needed a touch of indulgence."

"We drove up the coast and took a look at the Getty Museum which was lovely and then turned around and headed back into town."

"We arrived a few minutes early and sat in the car waiting for 7pm to arrive. In a few minutes it did but Poindexter didn't. That took an additional fifteen minutes and by that point

Maxwell had returned to that other man whom I had ridden down with, who was not at all himself."

"Finally Poindexter did arrive. It took an eternity of key fumbling and small talk to get inside. Poindexter attempted to continue the small talk; a drink was offered and so on but suddenly Maxwell begged him to just get on with seeing the mirror. I truly think that if Poindexter had not been of a mind to unload the mirror he would have sent us away right then and there. As it was he took a long deep breath, stared up at Maxwell and at length haltingly apologized with a tone and meter that led me to believe that he was pondering the termination of our viewing with each pause."

"As Poindexter was fetching the key for the locked room we were greeted with strange sounds emanating from it. Poindexter quickly walked to the door and pulled it open. There on the floor was the niece and her boyfriend: she a-top him both of them partly clothed and as both Maxwell and I realized at once, making their own use of The Mirror of the Sixteen Snakes."

"After the requisite scene, the recriminations the accusations of a trust being breached: the ultimate arrival at 'and what would your Mother say?' the girl stood up and while grabbing her underwear from the floor coldly looked into Poindexter's eyes and said 'Oh Uncle Bennett– spare me.' At which she slid back into her tiny black underwear, said to the boy 'For christsakes pull up your pants are you a pervert or what' and with that the two of them walked out the door and a moment later the shop

as well. Several seconds after the door slammed the pungent smell of smoke drifted to our senses. There was silence, more silence and then we all burst out laughing. We were still chuckling when Poindexter said, in a flourish of formality, 'Mr. Klopt, may I present you to the Mirror of the Sixteen Snakes. There will be of course an additional discount of 5% to compensate for the uh– miss-use.' Maxwell barely acknowledged the humor. He knelt down and peered into it, running his fingers over the snakes as he did, touching them all in sequence one by one following each serpent up across and thence back down; as if each one deserved specific greetings."

"'How much then' he asked. 'With the discount, $950.00,' said Poindexter. I near collapsed. Maxwell took out his check book and five minutes later we were in the car on the way to the motel the mirror wrapt in an old blanket and settled into the back."

"We didn't stay. Maxwell simply said that he had to go right then and there– I'll take care of the motel' he insisted– no debate. So we did."

"We arrived back in the East Bay in the early hours of the morning it must have been 2:30 or 3. It was a Wednesday. We stopped once, in Lemoore or Hanford: gas, a snack a coffee and a bathroom: But that was it. The fog was full and thick when we arrived. We came in the back way through the Caldecott. He maneuvered the Saab quickly up into the Berkeley Hills, made the turn onto Cragmont and dropped me off. '#545' he joyously proclaimed like a tour guide and he had me, my bag and with

a brief apology, out of the car and was getting back in and waving good-by before I could blink. The little Saab revved up and whined back down the hill, disappearing into the fog: the sound of the engine lingering for a minute before fading away."

"That was it. That was the last time I saw him."

"He phoned at mid-day but I let my machine get it as I was still trying to recover from the road trip. He apologized all over again and said that he was preparing to hang the snakes, which apparently he did. But he never returned my calls: He wasn't in Alameda and he wasn't at the Diablo house either. I assumed he was off after something else so I didn't think a lot about it at first. Five days later I phoned Bob Frye & he drove up to the Diablo house first and then back over to Alameda. In Alameda the door was standing open. There were tools and all the mirrors but nothing else. The police were only mildly interested. A month went by. That's when Bob hired the Fraser Agency and here we are: wherever that is: You, me & Mr. Simmer, Bob makes the quartet and who else cares. The Police just keep saying that they have been to both houses and there was just nothing to see."

The singular moment of clarity in the continuity of all of this, moving as it does, backward and forward along its own line of Time between an indistinguishable Past to a Mysterious present, is that at some point on a given specific day, shortly after or perhaps on the day of their return from Pasadena, Klopt

gathered together his tools, drilled three small holes in the old white plaster wall of his home in Alameda, expertly screwed in a mounting bracket and then, either reunited or joined together for the first time, The Mirror of the Sixteen Snakes and the mirror of Butterflies. He placed them upon opposite walls so that one might reflect the other. At some point after that, Maxwell Klopt simply or complicatedly disappeared. All of the carefully explicated and analyzed details, all of the various stories plots and sub-plots in the end relinquish only this; and even this moment begins instantly to diffuse beneath the weight of observation let alone differing perspective.

The morning that Rosemary Cross unlocked the garage door to the Alameda house it was cold and foggy enough to wet your hair. A stray gull called out from somewhere in the gray sky. We entered through a smaller door which was also locked, climbed a quick set of stairs and emerged into the kitchen. The little house on the estuary was dark. The electricity had been shut off for weeks and the lack of outside illumination conspired a darkness. The fog outside was thick enough to obscure the houses across the lagoon.

We moved through each room without talking. There was no wall anywhere that did not contain a mirror; a number of them held several. In the bedroom was a huge carved Victorian mirror in a gilt frame facing the bed. The bath had a long thin

mirror in a silver frame with embossed flowers running across its shoulders. We passed down a long hall with one mirror after another on both sides and finally emerged into the small formal entry-way which was finished in Cherry and was adorned with a lovely early-electric chandelier– one of those given away by the then new Electric Light Company of Oakland to entice would-be converts to the new technology.

Directly in front of the door off the left of the hallway we had entered from, was a small alcove with a wooden bench at its head. At the foot of the bench was a box of tools: a hammer, drill & level removed and laying near-by on the floor. To the left and right of the bench hung the Butterfly Mirror and *The Mirror of the Sixteen Snakes* not merely together again but actually looking into one-another.

As we stood in front of this small diorama I noticed for the first time how unusually silent the house was. There was no noise from the street, no sound of wind or rain, no refrigerator running or heat blowing. Yet it was more than a simple lack of sound: there was less than no sound: the interior of the house was an aural negative where it seemed sound had been pulled into a silent drain, like runoff from a swift storm whose windswept rain, which was only moments ago heavy, had now ceased just long enough for the quick air to wear away the wet, leaving now no evidence of the recent inundation, save the fact of the roiling clouds above. In short there was only the reflection of a sound here or there: the creak of a floor, a

muffled exclamation, a phantom noise whose source it was not possible for the imagination to find. In between these, as in a quartet playing on an old record-player, which had been slowed by an unseen hand, intervals of silence had begun to encroach upon and claim the space that surrounded us and we found ourselves involuntarily whispering.

The whole of it to take up another vantage point was like a cautious still-life from the hand of Vermeer. The tool-box acting as the requisite recently snuffed candle: The two mirrors, the clouded surface of the Butterfly and the almost unnerving clarity of the Snake, each mutely peering deep into the reflection of the other.

We found, as indeed the Police and the hired detectives had previously determined there to be, no other evidence anywhere on the premises to consider. Having spent the better part of an hour in the cocoon-like silence, we departed down the stairs and walked out through the wooden garage doors into the still foggy air; which had just begun to recede back across the bay toward its resting place in the Pacific. A dog was barking randomly; birds hidden from our view chirped over some excitement; a car door slammed.

Klopt had simply vanished: That is the long and the short of it. LOCAL FIGURE LOST IN REFLECTION, read the small

notice in the Chronicle. *Friends Reflect on Loss of Local Writer* was the painful headline in the Alameda Times Star. Even Van Amburg made mention of it on the six-o'clock TV news. But they too were far more interested in the mirror angle than in finding Maxwell Klopt; and in regard to the mirrors it was the reported accumulation rather than their history which made the event "news."

The note in the Chronicle did offer a little more with "the staff of the Chronicle marks the loss of one of its beloved" etc. etc. but even this was strained in light of the fact that of the three articles published by Klopt over nearly a decade (*Poetry and Science: A Reminiscence of a Grand San Francisco Festival* [1982], *The Sweetness and Greatness of Mr. Robert Duncan, San Franciscan* [1988] and *An Enforced Visit To A Near Miracle* [1993]) the only article of any length which had not been tampered with (meaning the only composition to escape the editor's insistence to "reduce by half,") was *An Enforced Visit*, which had received no editing by the Chronicle at all.

It was after his disappearance was noted in The Chronicle, which is to say after I became intrigued by the snatches of the story and began to follow its entropic development; that the volumes of Proust began to turn up at used book stores. First Powell's downtown, then Shakespeare & Co. and finally at Moe's; each bearing the date of reading neatly printed next to his initial on the rear fly-leaf in black ink.

It was a strange feeling when, as I thumbed the first of these volumes, I noticed the initials inscribed in the back. Having just finished *An Enforced Visit*, (which in its Chronicle appearance, had reproduced Klopt's initials in a tiny inset, delicately laid out between the title and the first of Caldwell's luscious photographs), my first thought was that I was seeing what I wanted to see. I thought only a little about it until the second volume appeared a day or two later while I was shopping at Shakespeare & Co. This time, upon finding that they were the same inscribed initials as on the previous volume, I went back to the Library to compare them with the original article. This in-turn sent me prowling all of the local used bookstores –making the rounds as I called it– almost compulsively for several weeks until I found the battered copy of *Time Regained* at Moe's.

That I came to purchase one of these would be of no consequence in as much as I am known to haunt the used book stores in the area: had I not found the second (volume two of *Within a Budding Grove* to be specific), I would likely have not pursued it further. But this discovery caught my mind and set me off in a way I can explain only by saying, as I said to the authorities when (having made no further discoveries for over a week), I turned the lot of them in and began my tenuous involvement in this curious sequence of events: "Indeed I do not know why I continued day upon day to search except to say that there was something so profoundly simple, unique, mysterious, seemingly dangerous, you pick a word," I said, "which

provided me a pleasure the likes of which I am, to repeat myself, incapable of describing."

To tie up the loose ends: It was while I was waiting in Chief Ivan Thompson's outer office at the Alameda Police Department that I had made the acquaintance of Ms. Cross.
The sixth inscribed volume remains missing. I still cannot go into a bookstore without first checking the P's.

Six weeks after everything settled down the phone rang. It was Rosemary Cross: The Mirrors were to be sold and she thought I might be interested in one of them.
I purchased the Butterflies.
We met in Alameda, entered the little house as we had done earlier. I stood between the two mirrors looking first at one, then, turning my back to the first, the other. I almost changed my mind and took the Snakes but frankly it was out of my price range and I found it as alarming as it was alluring.
When I finally took the carved frame loaded with awakening Butterflies into my hands and lifted it from the wall nothing happened: No dramas. The two of us stood quietly as we separated the pair once again and likely for the rest of time. Outside I could hear birds singing and the sound of one of the big fog horns groaning off in the distance. I wrote her a check and loaded my treasure into the car and left.

It was three days after this, three days after I had hung the mirror on the inside wall of my study up on the second floor: Just when enough time had passed so that it was edging toward a habit to be passing by its perpetually moving relief of insects, having finished up with the morning's work, I headed down stairs to get coffee and something to eat. I passed the mirror and was on the first landing of the stairs when it hit me: I walked back up and stood for some reason outside of the range of the mirror's gaze and leaned slowly over to peer into its cloudy surface. But instead of a murky pond-like exterior, I found clarity. It was by no stretch crystal clear or any such notion but I could now see my reflection where before there had been only the inference of a figure represented: An inference which previously could have been anyone, yet was now, me.

When you stand up close to a good Monet, by appearance it could have been painted in New York in the fifties. But take a few steps back and it swirls; a few more and a landscape emerges: rich, evocative; at times breathtaking in its rendering, its tenderness, its beauty; at others, exasperatingly obvious.

But I am always aware that someone had likely just crossed that landscape or had made her way around the painter as he worked so as not to disturb him: Or that some slight bit of color from a blouse, a twist of auburn hair, silently worked free by the wind, or a shadow elongating in the mid-morning sun until it was caught-up by the painter's eye and so rendered into the eternity of the picture, perhaps without thought; contributed itself as a marvelous passage within the composition and so then to the pleasure which I find there: A random contribution arousing my thought, moving within the composition and so carried on by the painting toward the next viewer. I am also aware that Pollock is said to have painted out sections in his big work that had by purest of accident taken on any aspect that might be read as "a figure."

This idea is constantly with me now as I look or read; even while I am listening to music. It is both invigorating and a caution.

Maxwell Klopt was never seen again. Three weeks later with the help of Bennett Poindexter, I sold the mirror to a collector in the east named Ashcroftte, and with the money I got I spent several days at Asilomar nested into a second floor room in Morgan's *Visitor's Lodge*, where with the fog in and a big fire in the downstairs hearth, I began this book.

4

****AUTOGRAPH

THE ILLUSION OF DISTANCE
THE ILLUSION OF PERSPECTIVE
THE REALITY OF REFLECTION

It was raining and the protective branches– long verdant reaching– of the low gnarled trees in the small square court-yard garden, which itself was surrounded by a narrow wooden porch whose imported cedar boards still retained at least the illusion of their original color –moved, just at the edge of perception, beneath the persistence of the steady round specific drops.

Through one of nine large near floor to near ceiling redwood windows, whose lower left and upper right surfaces were themselves clouded with a wet vaporous slowly expanding storm, David Leering sat, watching.
In his hand a cup which he had pressed firmly against his lower lip, let loose a thin trail of steam and aroma that spiraled upward, gently twisted itself across the length of his long aging

face and disappeared into the cool air above him. He sat. At
length he brought the cup to his lips and took a brief sip.
A fire pulsed in a small wood-stove and pushed a column of
warmth into the room with just enough effect to reduce the
chill he had awakened to.
A window had been left open on the far side of the court-yard
which allowed the cooldamp pacific air, the sound of the drops
and the mingled aroma of fallen blossoms to mix freely with
the earthy scents of compost and wood-smoke before quietly
blooming into the smells that would now and always be this
morning.

The telephone, which had not rung once in the six days he
had been staying in this house, continued its silence into the
morning's damp. Each sound in the open room: cup to sau-
cer, hot-wood-snap behind closed stove door, tick of warming
metal, rustle of paper; were all hollow, particular; at once near
and distant.

From a thin glass french press-pot held by ornate darkened
brass filigree, which itself was held by an aging wooden handle,
he poured-out the last of his coffee into the thick green ceramic
cup letting the liquid fall in a narrow arc that trickled through
a scale of ascending tones to alight upon another silence.
He thought of the cup, small roundish black, a cream colored
circle at its center in which a tiny drawing of a hammer was

floating in the air. Beneath it a caption read "screwdriver as hammer." It was purchased from the street vendors in Berkeley and given to him by Maria Kostello a year or so before her death. Gone now it was along with everything else in the earthquake six days ago.

He felt slightly cold again.

He returned the press-pot to its tray which protected the silky-fine wood of the antique table beneath it from any accidents. The rain began to pick up in intensity, the wind jostling the square circumference of the court-yard with a firm moment of submission. The front, classic fall pacific, he thought, was about to pass.

He stood up and crossed the room with several brief steps until he reached the glowing door of the stove. He opened it and savored the escaping warmth and smoky sounds of inhaled air for a moment before reaching down for what was the last of the morning's supply of wood. He carefully placed it onto the thick layer of coals, closed the cast-iron door and returned to the comfortable folds of the victorian couch he had nested in.

Everything was gone. From the large to the small; from books and manuscripts, clothes and furnishings, to the small bits of bark and a rock collected from some day of significance and

long ago made into an arrangement which had then become a Place: All was now gone. The Habits of a day; coffee in the morning with the perpetually used cup selected from amongst the twenty others, a book for reading in the bathroom, the place on the couch which supported his back, the feel of the long used towels after a shower, the mid morning calls: all were now collected and hung upon him in memory only like a borrowed suit jacket which almost fits, in fact does not look at all bad and yet was simply not his. Even the image of this seemed ungrammatical and borrowed.

The water tasted strange. He felt the discomfort of simply being noticed; of having to ask.

It had been a relief when Katherine had left. Her business trip east had been pre-planned, and while delayed by the earthquake it was still a necessity. Her hospitality had been enough. She had settled him in with a minimum of embarrassment and a subtle proficient dose of sympathy.

Yet the strangeness of being in her home without her would not let go of him and as familiar as her Potrero Hill home was, the strange now had a greater presence.

He stood again and crossed to her huge wall of books in the adjoining room and pulled down an older looking volume running his hand across its embossed spine as he did. In flourished letters it read: *STILLTON* and at the bottom: 1607//1855. The spine, darkened by the caress of numerous other hands, formed

the bark of a greatly gnarled tree whose branches twisted onto the front and rear boards, shading the embossed title, which read merely: *Complete Works*. Opening it he thumbed a few pages and at random read:

> **Orlando:** Across hunting run down like a rabbit in
> June air the heart repels the ravages
> of collecting days and staggers to thwart
> further the ascending landscape of discovery
> that awaits each fresh daylight.
> Do you then wander or to rephrase
> do you then have Strength to Wonder
> and in so doing wander on alone?
> Or will you let twine bind you into a collection.
> Bend down Old man beneath this freshening breeze
> and let down let down the loose verse
> of a turn toward the sun and it will renew you.
> A Word then in a phrase if you will. Allow me to go on.
> Let the heart fill with a language of arrival
> that serves only to review and breathe deep
> that chill as it arrives.
> Depart: and as you do twist.
> **John:** [standing from his desk with his back to Orlando]
> Will you now attempt to instruct me as well?
> Am I no more than your habit worn out
> and now to be set aside.
> **Orlando:** But you are my life-

John: Then address me as such.

Orlando: –Dear Life

John: [turning toward Orlando]

Who are you that comes here thus

Orlando: I might well ask of you the same.

That I cannot but dream of a breath without your

pen plays rampant with my thought.

John: then be silent

Orlando: As you wish. [He turns and disappears]

John: This all feels too temporary for a life and

too isolate for an annoyance.

Dear God it is cold in here this morning.

Is there to be no fire today?

Are you not chilled to the bone

Orlando: Are you addressing me? Oh I should hope to

think not.

Take up your instrument again

old man and write me

But do not mix me with your domestic tranquilities

I am no metaphor for your device but as lung to breath

delight in your rising thought when you think of it.

John: Am I now no more than a character within my

own life?

Orlando: Are you to return to this subject again?

I should think it played.

John: This is no play despite your claims otherwise.

Orlando: My claims otherwise do not a debit make.
Yours on the other hand weigh heavy upon anything not
rock.

When Breath is facile and the Night
reigns over animation the seed of being
emerges from itself
to ring like a bell within the draw and pull of a quill:
Days emerge like seedlings to twine and twist across
the folds of fertile pages which
beset us with thought not ours
yet now ours in Hours now
Claimed by no authority more than the Love of
Sweet quiet and the thought of sitting alone in thought.
By Choice we push fate aside and draw out of that
bounded Other
a freedom which in its range
is like no familiarity which we know, and yet
we come home come true come in fact or fiction to
what we know to know. We are each of us in this
Love's instruments. Not even in Lovemaking do we
find such complete intimacy with another mind–
John: Oh do go on I sensed an arrival.
Orlando: Only a return. True arrival is a rare
friend. But in truth I have but
stumbled once again into my subject

John: And that would be?
Orlando: Indeed it would

He closed the book and replaced it amongst the host of others on the stiff shelves which held the populace of the Library and returned to the couch. The image of Stillton, arriving from out of nowhere, came to him. In the small day-dream he repeatedly saw Stillton walking across the bottom floor of his house. The light was gentle with early morning: The silence discernible. Stillton placed a large bundle, the manuscript of the recently finished *Orlando*, onto a small walnut table in a long hallway. He reached up and removed a chestnut colored great-coat from a thick brass hook and with a modest sweep cloaked himself into its woolen warmth. He took up the bundle and headed down the hall to the front door removing a wide brimmed hat from a table as he did. There was a hint of a slight creek as he took the iron latch into his hand and swung open the thick wood of the tall paneled door. He stood on the top of his stoop and with a habitual gesture placed the hat onto its proper position atop his head. He descended the stairs and headed south along Hersey Street toward the Theater. His breath vaporously swirled from his mouth. The clock-tower announced the hour. "Brimmerton will already be waiting," he thought unconsciously shrugging his shoulders as he did; a hint of exasperation escaping with

his breath. But this did not in any manner diminish the satisfaction of being finished. He had, he knew, made a world. It was as simple as that. If Brimmerton found it wanting, it could not diminish _that_ fact; it would merely return this world to his box of manuscripts where it too would wait. It had been twelve weeks of rather continuous work. Twelve weeks in which the six characters of Orlando had arrived in the mid-morning hours, arguing posturing teasing with words he felt he must chase to collect: And yet in attaining them the chase was at once replaced by the necessity of not crushing the life from them with his firm grasp. Twelve fine weeks. The rest was not his concern. He chuckled at his hubris. He felt annoyed that he had allowed Brimmerton into his thoughts on so bright a morning as this.

Brimmerton's rather jovial demeanor had in short-order become a repressive presence. That the young Bremerton was forward to the point of offensive was of course well known; but it had always been pinned to his notable creative skills: skills which were indeed far beyond his years.

But what had at first seemed to be character, had now molted into an insatiable need to control everything and everyone. To protest this need, even slightly, was to find one's-self locked into mortal combat. Any point no matter how slight required an immediate rebuttal. He had perfected this practice to such a degree that simply ignoring his voluminous abuses was not possible. Each "suggestion" as he called all criticism, was baited

with a hook whose barb was at least the hint of a humiliation that one had not seen the "suggestion" for one's self. Stillton felt flush with past altercations and suddenly caught himself. He stopped full in his stride and took a deep breath allowing the chill to fill his lungs; the cold to caress his face and clear his thought. He exhaled and said aloud: "not this morning young pup; not today." He clutched his manuscript to his stomach and began to walk again with conviction and within a block had regained himself.

This scene of Stillton ran through Leering's mind twice and as it began to play out for a third time Leering reached for the notebook which he had purchased the previous evening at Petini's Stationery in North Oakland. His hand in turn habitually reached to his shirt pocket to retrieve his fat black fountain pen. But it had been laying on the kitchen table with his notebook. He had abandoned them both to watch a bit of the world series leaving the new set of poems, (which he had come to during a late morning walk across the Mills College campus where he had gone to meet an old friend for lunch), to be followed after the game. He fumbled for another pen –chased back to reality by these thoughts– and finally found a thin blue bic whose top was slightly chewed. He then recorded the small story of Stillton into the empty still stiff notebook.

A loud pop from the fire interrupted his thought after which he could find no more of the Stillton story to record. He closed the notebook and placed the bic next to it. Then after a brief pause he placed the bic into the folds of the notebook.

"*Collecting Days*," he thought. Across the room, the library wall, illuminated from its own un-curtained court-yard windows, was a palette of grays moving to black and white with eruptions of color here and there from the more adventurous bindings. "How many days lived, (which he quickly corrected to "live") collected within each book." The thought and its syntax caught him hard enough to make him repeat it aloud, twice then after a moment or two, a third time. It seemed at once so completely obvious and yet penetrating; but penetrating into what? And if it was indeed so obvious, he thought, why could it not now be named?

The concept of thoughts recorded into any given book, held there to be released to the reader, was of course an ancient one. Even prior to the invention of the book the idea of the Story-Teller as a bearer of knowledge from the past was well entrenched into the imagination of those listeners who waited, gathered together at campfire or hearth. Yet it was the events or heroes of other Times, other Places and their Story or Stories that the Story-tellers, like bees covered with pollen, carried from hearth to hearth village to town to city.

But the condensation of days and hours and minutes, (within

the narrative and more importantly within the very compo-
sition of that narrative), into a central location, held there in
the amber of binding, paper, thread and ink to be released
at the will of the reader, (it was after a moment's pause that
he underlined these words with a rather heavy hand), flowing
out from the static world into which they are bound into this
new and timeless host of their existence who sits motionless
before them, waiting; this is of our time. In this somewhere
somehow the common, what Gertrude Stein named "daily liv-
ing" blossomed into the exquisite and became an equal of (if
not at times a more honest pursuit) than that, as it had been
called in the old times, "*of the heroic*": At that moment when
the clear articulation of daily living gained the possibility of
an equality to the heroic, the nature of Time changed. Days
accumulated not merely in the event but in the life of the
writer as well and so then on the written page: The knots of
thought could now be left tied for the reader to stumble over,
just as the writer had, as he or she rambled across the field of
the would-be book. These days, if not specifically then certainly
their overtone, their eventful shadow, flowed silently across and
into the confines of each book each page of each book and each
sentence of each page where trapped, they lay latent with the
effects of event's minutia, waiting to be silently released into a
welcoming imagination.

We are, at least some of us, sensitive, he wrote, smiling slightly
as he did, to the effect of this condensation. I myself am clearly

aware of some alteration in the fabric of time when I enter a library or a good used book store. On this trajectory we arrive at the curious habit of silence which has risen to a Law of behavior upon entering a Library or even a book store. As life does not normally offer nor do we require such silence for our reading, one is left then to ponder the Source-Delphic respect we attire ourselves with when confronted by a Library.

From where I am now sitting, within the room, which like a landscape, viewed across furniture and wood floors, bathed in diffused oceanic light, I can hear amongst the numerous shelves of books, the murmur of Days, waiting.

He continued along this line of thought, following its tangles and turns into gibberish. He drew a large line across the page with an empty space between it and the previous words.

He re-read what he had written and marveled at the change in tone and language his normally easy prose had morphed into: A formal near professorial tone. He smiled thinking as he did that the bastards had him by the toe: Yet he continued.

Ultimately then, he concluded, we now write not to record histories or events of a life but to capture and hold specific moments where thought becomes easy or momentarily clear: Where our senses quicken and are filled with an alignment to their ancient past and at the same moment cast themselves toward our future and in doing so bring into relief the ongoing

moments of that life's searching. Ultimately what is caught up in such activity is Time. But this Time is defined by a single being moving through it. This in turn may impart not a lesson but a commonality which may in turn guide us not by rule or goal but by the simple comfort of Being.

The past then is not re-captured. We emerge into a moment specific and charged, with a clarity of mind that simultaneously Knows and feels that moment, that clarity, to contain the greatest human possibility for awareness: And for that moment only we See. Time spills forward; everything is consumed by the future: All from a moment no more nor less than completely common or familiar. This is not a matter of semantics but of direction. We stand on the edge of a waterfall: the water plunges swiftly away from us into the future and it is there and only there that the past can reside. The Now futures like a wave cresting. What we see is not its crashing conclusion but the slope of its rise the white-wash and spume of its trail which is ever before us. If we enter we are pulled along by its current. If we stand but near-by we can none-the-less still feel its flow, the wet articulation of the air.

And so a book, just as the accumulating flow of a stream, will deliver the past text of a day, an hour, a moment's passing, to that small rock upon which, feet wet cuffs damp, we stand. But again the past exists only in the future; and Time, fugitive anarchist that it truly is, is unmasked in a penetrating moment of clarity: A clarity which the mere sight of shatters. In its place

the clock tick of a day's hours returns and we find ourselves in
our chair or bed, or upon this russet-colored couch on which
I am sitting as I write, thought meandering to focus, departing
yet another Country; closing yet another book.

The temperature in the quartet of rooms surrounding the
court-yard windows dropped to the point of being noticeably
cold.

He stood again placing the bic-pen on top of the closed note-
book and crossed the room to check the wood stove. The
embers still glowed within it but it was obvious that they would
not last much longer. He decided to fetch some wood and this
of course meant going out into the rain to the neat wood-pile
which Katherine, with great care and energy, constructed at
the end of each summer.

As he began to cross through the library he turned abruptly
from his path and grabbed the bic pen. He replaced its top
and returned it to his front pocket.

The wet air that met his skin as he opened the paneled glass
door at the rear of the library lightened his mood. The rain had
succumbed to mist and the trees near the long delicate stack
of wood relinquished from their upper leaves the only physical
drops of rain; two of which caught him directly atop the crown
of his head making him take a half-turn toward the center of the

court when they did. He collected a nice bundle of wood and returned to the stove. In a moment he had it fired again with a mix of small and large pieces of the oak and cherry woods. The hint of smoke from the stove returned his friend Christopher Muir to him. Christopher Muir took great delight during the Xmas season (this whilst they were still in high school), in riding the cable car out toward the wharf. At some point when there would be just the proper number of tourists aboard, he would say something about the brakes being made of wood; loud enough to be clearly heard and with enough detail, (wood types used over the decades and so on–) and an authority in his voice mixt with ever the hint of secrecy, to command the attention of the surrounding tourists. When the cable car finally began its descent, more of a plunge, toward the bay and the brake-man had reached deeply forward and hauled the great break-lever up in a circumscribed arch from floor to chest as if the conductor were taking it literally to heart; the inevitable and quite normal perfume of smoldering wood would drift into the car. There were times when a notable silence would envelope the resident tourists. Eyes would widen. On one occasion the driver having taken all this in announced "Don't worry folks it's probably just the old brakes: If they don't stop us there is always the bay" (here there was a wonderful pause) "which will at least nip the fire in the bud."

Closing the door to the little stove he paused as it picked up in intensity, enjoying the rising warmth which seemed to collect

the damp from him as he waited. He opened the door again. The rhythm of the fire drawing in air from the room made a muffled roar, periodically snapping and clicking as it did. He watched for a moment and then closed it again. He returned to his spot on the couch. The bic was in his hand and without thinking he drew a long double line across the page:

[JOHN DEE AT MORTLAKE]

At Mortlake, in the year prior to the destruction of its Library, John Dee lived out his days amongst the thousands of books, maps, manuscripts and scientific instruments which he had painstakingly collected over the coursing twists of the years: A collection that was in-fact more of a history than a simple gathering of artifacts: His Library was a world: A complete world with a past present and future.

Earlier in his life, when the English conservatives were disman-tling the hierarchy of their equally oppressive counter-parts in the Catholic Monasteries and sacking their Libraries, Dee had placed advertisements in the London papers with offers to pur-chase any and all books and manuscripts which had somehow escaped destruction. The effort had proved worthwhile to say the least: In point of fact it was an Act notably singular and without Authority or Academic permission. It was an act which had at the very least offered the possibility, by which I mean a Place, a touch-stone, an unencumbered point of Source which could be (and was), nothing short of world altering.

He befriended the young Elizabeth Tudor and was later to cast the astrological chart which would select an auspicious day for her coronation.

He traveled and collected, lectured to acclaim on the continent, married and shared his library with anyone willing to make the trip up the Thames. He wrote the introduction to the first english translation of Euclid: an introduction, an event really, so influential that certain scholars have rooted the blossoming of the English scientific revolution into its publication. He is like-wise credited by some as sparking a similar revolution in the English theater of Inigo Jones, Johnson, Stillton and Shakespeare. Jones specifically but most likely Stillton and others made use of his Roman books (notably Vitruvius), and took away an inspiration so deep that it opened a reimagining of the possibilities of the Theater which still governs us today. [Francis Yates makes a marvelous argument in favor of all of this which any theater lover or Poet would enjoy an acquaintance with. *Cf. Theatre of the World, 1969*]

In 1583, shortly before his departure for the continent to visit Poland, he made an inventory of the collection. Shortly after his departure, a mob, convinced that Magic was being practiced on the premises, broke into Mortlake and destroyed what is likely a quarter of the books in the collection. (The mob's assessment was of course correct: The science of calculation combined with the Wonder of thoughts that coalesced into the pages and pages of books, manuscripts and instruments had

naturally led toward the thought that those same calculations and operations would open the universe and conjure angels. Dee's assessment was of course, also accurate.)

But it was the poetics of exchange, which ultimately had the broadest effect, rippling across the human pond to a far shore upon which I am even now standing. This Poetics, this urge toward inclusion and community (so dearly felt by Dee and his extended company, which, as is always the case, somehow surfaced and flourished despite those ever-present forces of negation, separation and isolation which *constantly* attempt to rule the various modes of living and expression); is an urge which repeatedly continues to come forward, (wriggling up through the soil of the present to emerge, like Mole beneath the Willows, nose up and turned toward the smell of the River), to set itself on a path away from the multitudes of the negative– destroyer of spirits and of worlds.

In the last century it was Darwin, Marx, the community at Brook Farm and the curiously Dee-like Walter Whitman who were its most notable practitioners. It was glimpsed most recently, for a few exquisite months amongst the merry pranksters. It is always present, always dispersed. It will surface again: Of this fact we must have faith.

While surely aware, at his age, of his own mortality, John Dee had not expected to be pre-deceased by the inhabitants of his Library. It was an experience which he took dearly to heart.

Late in life, abandoned by his friends at Court, impoverished, he sold not his Library but individual books, one volume at a time, so that he could eat. And so then at one and the same moment are practicality and true heart-break defined.
In the face of destruction and starvation dispersal is a sweet mistress. Any rose standing at the tip of a sturdy stalk in late September knows this.

[this section does not fit and <u>should</u> be cut]

– he wrote, underlining the word *should* and with this emphatic emphasis rendered it ambiguous; as if he should possess the discipline to remove this dangling tale yet in the end did not possess the strength necessary to do so. Further complicating even this is the fact that it is not at all clear whether he means the rose image or the entire passage regarding John Dee.
In the notebook there follows a group of drawings– near-doodles yet somehow owing to the clarity of the hand and the energy of the imagination; more: And this is followed by a final entry:

FOR AS LONG AS I CAN REMEMBER I have been going to build something in my garage or basement.
As a child and this was as early as fourth grade, I was going to construct not merely a space ship but a complete NASA Gemini

capsule. There, in my back-yard as my imagination projected again and again, I would, with some imagined friend (whom I had not yet met) be able to sit, as those astronauts whose first attempts at space-flight did, confined, busy, surrounded by dials and gadgets to check and recheck, all while the immense complications and calculations and delays were narrated "live" by Eric Sevareid, Walter Cronkite, Huntley or Brinkley and a host of other storytellers speaking to me in the dark of my room from the luminous glow of a black and white TV screen. (I had awakened myself for the first Mercury flights to watch in the pre-dawn hours of a second-grade school day (a school-day which my mother must, I now realize, have allowed me to skip.)

It was a fourth grade dream; in other-words a lifetime ago.

I invited Carol Lebervou, on whom I had a fourth grade crush, to visit the small construction site laid out on the walk-way between my house and the surrounding fence (the approximately five feet which constituted my Coronado back yard) and there I boldly told her of my plan. I can only speculate what she made of the random pile of wood and tin-cans and green bottles that I had collected for the project: which was in fact the only evidence of my project. It all seemed so clear to me.

In my twenties it was a print shop that was to go into the dust filled dilapidated carriage house of the old farm house I was renting in the east bay; in my thirties again it was a print-shop this time in my basement; now it is a place for poetry readings

within finished walls and on an antique floor surrounded by a garden (which one must walk "through" to "arrive") a collection of books brought to the room by every local poet who would contribute a book of singular importance to their idea of the art– the printing press which I am to restore looming as an important decoration; an Ark of poetry then, gathered against the local school-born ideas of poetry and held in one place: A library of the Beloved.

But in each of the various manifestations it was or is to be a Place: a sense made up of other such senses; none of them my own. For I have come to know that "I" am derived from the double hurricanes of 1954 Providence, the wax-making room at Mt. Vernon whose perfume I still attempt to elicit in my own home or at least I used to: The light at Williamsburg (a place out of Time which I believed existed, entered by some magic (performed by the enactment of my father's keen interest in the small and large objects and the Place as well- and the very tone he used in simply naming our destination), which allowed our access); the sound of the wind rising to hurricane force, (the tone actually falling to a deep ballsy rumble), the feel of the pressure lowering in advance of the storm– one night in particular while visiting an old Victorian house near Virginia Beach & the preparations– drawn water, candles distributed, food laid in, shutters shut, everything battened down; or second and third grade-age & walking alone in the Virginia swamp or its near-by woods, catching crabs in the bayou with string and

raw meat to carry home to my mother on my bicycle, the rain in summer intense thundering which I happily rode through, the first flush of fall air pushing south, the random snows or the one great ice-storm where our Volkswagen bug (one of the first in the area) was one of the few cars able to travel; the slow ride across San Diego Bay on the aging Coronado Ferry; the Pacific Ocean near the even older Del Coronado Hotel, alone- with my balloon-tired Schwinn bicycle waiting for me outside; the slow approach of my father's ship as he returned from a six-month cruise on that same ocean, the desire for his embrace, each moment a minute each minute contorted into an hour in my ten year old heart, (a desire returned now by his death so that I struggle as I write this with the Thought of Him), the sound of the rain on the roof of our first house in Coronado actually an apartment– flat-roofed and tucked into a forest of vegetation on Olive Lane– my bed, sitting atop a chest of drawers and surrounded by book shelves, mounted by a short ladder; Florida and friendship Mark Knisley and drumming and first love all within a slow-quick-arch of 14 months; Arizona the desert air and light and isolation as I had never known or rather was now old enough to know that it was isolation: Henry Quiros and Dee Dee (who like a flood filled my dry self with a friendship the thought of which still sustains me) and music and more music but friendships never to be replaced; then on to or home to San Francisco and 1968 and everything which that means all wrapped into the Pacific fog and wet

air and San Francisco and Joe and Chris, and Doris, Fran &
Madge, Robert Duncan and Jess and the Grateful Dead all
flowing into adulthood; opera and Mahler and so on still flow-
ing to where I do not know: Each place a sense each a silence
each a Place within my imagination that must somehow be
reclaimed.

How then does this all fit with the where I am?

I often...Often I am...

I

It was raining.

NOTE:

The manuscript of Autograph, or to be absolutely accurate, the small notebook which contained it, which surfaced only recently, was discovered by the sister of Katherine Cross-Alexander. [Ms. Cross-Alexander as is widely known became a victim of the recent unpleasantness in September of last year.] Apparently Leering had slipped the notebook onto a shelf in her considerable library. The elder Ms. Cross discovered it there while composing an inventory of her late sister's Library for the estate. Already aware of the publication of stories by "her sister's friend," she brought the notebook to the grateful attention of the editors, who unanimously decided that it should be appended to the other "Marvels."

A NOTE ON THE TEXT AND ITS AUTHOR:

There remains a great deal of miss-information on the subject of David Leering.

The facts are that he was born in the city of Coronado, California and that he lived for much of his adult life in the San Francisco Bay Area. That he died somewhere within the state, is assumed. That the very structure of these facts mirrors all that we believe about Mr. Leering's biography is instructive.

It is assumed that the MARVELS were composed sometime in 1994.

Although it is thought that he wrote constantly over the course of his adult life, the MARVELS are his only known manuscripts. These manuscripts form the only collection which has reached the public.

His home in San Francisco's Marina district was destroyed in the earthquake of 1989: Yet it was not the actual earthquake but a toaster which he had just begun to use at the precise moment of the quake. It caused a power surge that in turn ignited a fire which in turn rapidly destroyed his home, burning it to the ground.

It is said that in addition to his art, a sizeable Antique collection, furniture and other personal belongings, the fire claimed a sizeable

archive of manuscripts, notes, signed editions of poetry and other personal papers.

The end of Mr. Leering's life is no less ambiguous than its beginning is clear. As has been recently reported it was shortly after finishing the fourth of the stories published here that he disappeared. His body was never discovered. He was declared legally dead in early 2000 and his estate was delivered into the hands of the late Johnson Rowley, his godfather. Upon Mr. Rowley's death a mere four months later, the manuscript [of the first three tales], as assembled here, passed into the hands of a Berkeley book dealer named Simpson Brown. It was Mr. Brown (and of course subsequently Ms. Cross in regard to the fourth tale), who brought them to the attention of the editors. He also saw the original limited-edition through the press.

This new edition has afforded us the opportunity to silently correct a number of questionable decisions and typographical errors housed within the original limited edition. Deepest thanks are in order to the Publisher, Copy Editor and Designer of this edition for their faith and endurance in seeing this book through the press.

o o o

The photograph on the cover is used with the permission of the artist, Edward Caldwell of San Francisco. The quotations from the unpublished poems of David Miller are used by permission of the estate of Estelle Wentworth. AN ENFORCED VISIT TO A NEAR MIRACLE is used by permission of the Chronicle Publications, San

Francisco. Robert Duncan's Heavenly City/Earthly City is quoted from the volume of that same name, published by Bern Porter, Berkeley, 1947. We thank Peter Howard for supplying a copy for our, as he so succinctly put it "temporary" use.

[As the poetry of Mr. Jalabiense is still but little known outside
of poetry circles, the editors hoped that the inclusion of the
following poems, translated by Geoffrey Broaden in the 20's
might offer both a pleasure to the reader while extending if
but a little the world of Mr. Leering.]

Jalal al-Din Jalabiense:
from: THE LEFT SIDE OF THE SERPENT'S TONGUE
lyric apparitions & throatsongs
Paris, Contact Editions, 1928.

Recalling Blake: *The Authors Are in Eternity*

i
Still trembling in the flowering
garden where winter's empty fingerprints remain

in the mute scattering of birds,
I search for seed and collect only a stone
small round and black-grayed by Time
which into my pocket as easily as a thought to mind
disappears to be carried away and found
whenever I reach for something else again.

ii
but delicate the feet of birds

in a dust of a mostly green yard
draws time beneath me to
a numerous direction
that otherwise –in a ripe garden
would be lost

iii
or a cloud passing shadows my own
feet for a time
to define passage and
so release what it easily claims
The leaves take no notice of this but follow

a different movement leaping in an end we define
to claim a shadow of their own
for color.

iv
which makes them fall my son would say
 at three a proclamation
 sure and good enough
 for emphasis
that color and shadow have equal weight
and a design
I am still ill-
-at-ease with
he saw clear without the encumbrance of
a pocket
full of
small stones

v
but my dust is the clearest
hieroglyph of this garden

and my birds or their
Master, the wind, its author who

claims in the design
a transient participation
in a true Nature
whose song, whistled in the
cracks of these old windows

moves this hand that leaves
only an inky stain behind

vi
morning landscape and
a thousand poems
glisten at the ends
of tall green grass

I prefer this light
now thinning towards evening
and the singular noise
of this late bird whose

whistle has apparently now called a
half moon into the still afternoon light

vii
a thousand poems? a thousand clichés

a lilac vining across the wood of a fence
while a zinnia pokes through the square dirt where a
stone has come loose from the drive

 I avoid it and walk back
 up to the house

dust darkens the tips of my shoes
The wind
has now turned toward other
concerns: rain
at day-break or
a little fog come up from the sea in its place

everything returns
 my coffee will be hot
 the air, cold and wet, windows clouded
from the accumulations of my

still trapped breath

every morning I go back to my yard down
the drive past
the zinnia

and attempt not to sit in the same place.

CODA {while reading again in Rumi}

for now let your Heart drift slowly
toward your Dreams where
from music they will form
to give up the beat
of such dance as you
are capable of making

The dark around us fidgets
and turns gray beneath
the weight of silence.
Stars emerge. The Moon
rises. Death toddles beneath the wait of Eternity.

I eat fruit. Peaches

if I can or a plump plum
plucked from full summer sun still warm and as
full of itself as I am
so that words run
like dreams on this
black inky stream until
they release the beat
of a Heart that would
slip through Time to you
who also wait

ii
If you call me I am complete–
 music is still a full meal
when such darkness as walking
alone amongst people
walking together becomes
all one eats

Even the aroma of a rose that
floats on the air alone above the
perpetual noise of traffic

needs a nose and a deep breath
to find its way

iii
Each of us is Seldom
My destiny – your throat
where
as a vowel I
will tremble
until you swallow

(I
 in turn having
already dined
well
will not follow.

[facsimile of the original colophon page]

PRINTED ON THE OCCASION OF

"DAVID LEERING: A SYMPOSIUM"

ORGANIZED BY THE LATE MARY LOU FITZGERALD

AT THE KAEL / BASART HOUSE

FOR THE POETRY CENTER

AT SAN FRANCISCO STATE UNIVERSITY.

OF THE FIRST EDITION OF THIS BOOK:

250 COPIES WERE PRINTED

OF WHICH 26 COPIES WERE LETTERED

AND SIGNED BY THE EDITORS

FOR DISTRIBUTION TO THE FRIENDS

OF THE POETRY CENTER

AT SAN FRANCISCO STATE UNIVERSITY

this is copy # ___ of 26